IMAGES
of America

BROOKWOOD HILLS

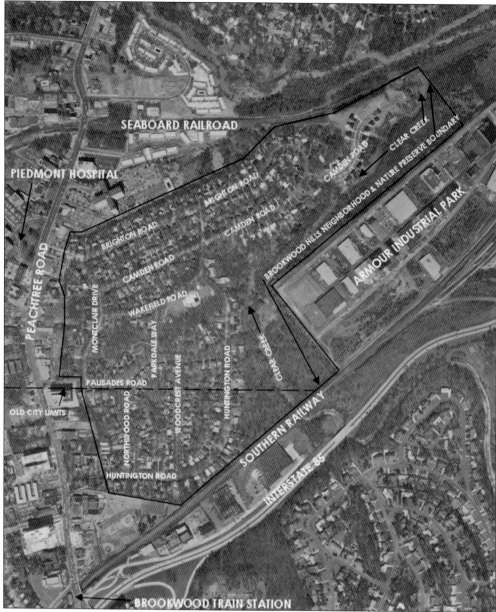

This aerial photograph from 1964 shows Brookwood Hills (outlined in black), a historic district listed in the National Register of Historic Places. Developed in the early 1920s, the neighborhood has long functioned as a green oasis within its urban surroundings. (Courtesy of Georgia Archives, Atlanta area aerial photographs, 1964, image number 48-972; labels by Joe Gardner.)

ON THE COVER: Mable Pentecost and her children (from left to right) Mark Jr., Ann, and Jean pose in 1929 with their new roadster in the backyard of their Brookwood Hills home. Young Mark grew up in the neighborhood, became a physician like his father, Dr. Mark P. Pentecost Sr., and returned in 1957 to purchase a home in Brookwood Hills. The two-story garage in the background served as author Pat Conroy's office in the 1980s. (Courtesy of Martha M. Pentecost.)

IMAGES
of America

BROOKWOOD HILLS

Betsy Crosby and Elaine Luxemburger
Foreword by Ed Helms

ARCADIA
PUBLISHING

Published by Arcadia Publishing
Charleston, South Carolina

Printed in the United States of America

Library of Congress Control Number: 2013941705

For all general information, please contact Arcadia Publishing:
Telephone 843-853-2070
Fax 843-853-0044
E-mail sales@arcadiapublishing.com
For customer service and orders:
Toll-Free 1-888-313-2665

Visit us on the Internet at www.arcadiapublishing.com

This book is dedicated to the many Brookwood Hills volunteers whose remarkable community spirit over the last nine decades has helped preserve this unique neighborhood.

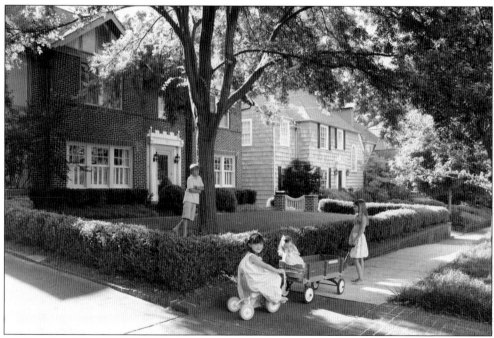

Brookwood Hills, a walkable community within the City of Atlanta, has maintained its architectural integrity and community vitality since it was first developed in 1922. (Photograph by Kem Lee.)

CONTENTS

FOREWORD

I was raised in Atlanta, Georgia, a big city by any measure. Whether it was trips to Fulton County Stadium for Braves games, a new exhibit at the High Museum, or ordering a "naked dog walking" at the Varsity, the scale and energy of the Big Peach was always apparent. Which is why it may seem odd that I actually feel like I grew up in a small town. That is because my neighborhood, Brookwood Hills, is where I caught frogs in the creek behind my house. I heard the lonesome whistle of a train going by just about every dusk. And sometimes we would even hop the fence and lay a nickel on the track.

I had Little League practice in the park and hit tennis balls at the community club. And my first job was in the concession stand at the pool, where I eventually worked my way up to lifeguard and then assistant manager. My street was teeming with kids; we played kickball in our yards and even cut our own BMX track into the woods at the end of the street. Come Christmastime, we were often caroling around the neighborhood. Was it a nice place to grow up? Let's just say Norman Rockwell would have had a field day.

—Ed Helms

(Photograph by Jason O'Dell; courtesy of Ed Helms.)

ACKNOWLEDGMENTS

We are extremely grateful to the Brookwood Hills Garden Club and the Brookwood Hills Community Club for their sponsorship of this book, allowing us to record a history that has been fast disappearing. We also wish to thank the family of B.F. and Arthur Burdett, especially Lisa Burdett Paine, Claire Burdett Simpson, and Jenny Miles Paulsen, for sharing so generously their pictures and stories of Burdett Realty Company and the neighborhood's original development.

Our research began one languid August afternoon with four ladies who spent their formative years in Brookwood Hills. Thanks to Margaret Evins Shirley, Bitsy Wesley Boozer, Fran Milton Patterson, and Clara Mont-Claire O'Shea for inspiring us with their memorable tales. We especially thank the many other current and former residents and their families whose photographs and stories are scattered throughout this book. Thank you for opening your homes, your scrapbooks, and your hearts to us. We wish we could name you all.

We would like to acknowledge the Legacy Ladies, who collected the historical information now housed at the Kenan Research Center at the Atlanta History Center, which supplied the backbone of our research. Thanks to Anne Donaldson, Nancy Kennedy, Alex and Kay Summers, Jim Stokes, and Jerry Luxemburger for their recollections, photographs, and documents regarding crucial times in the neighborhood's history. Hats off to Mary Lu Mitchell, Lynn Petters Cochran-Schroder, and Lucy Carpenter Vance for their persistence in tracking down stories and images, and to Skip Petters for a great hamburger at Ted's.

We are indebted to Brown Dennis, Betty Black, Floyd Newton, and Linton Hopkins Sr. for pointing us in the right direction, and to Joe Gardner for his grand perspectives. We also thank the many well-wishers and fellow history buffs whose efforts, large and small, helped illuminate the story of both Brookwood Hills and the general area called Brookwood.

Deep appreciation goes to Ed Helms for contributing to our project; Kem Lee for her superb camera skills; David Watson, Bob Long, and Robert Jenkins for their assistance with Civil War history; Dr. Sarah Hill for her help with Native American history; Wright Marshall for his research on architectural history; and Anna Cate Little for her copyediting assistance.

Thank you to the many librarians and archivists who helped us navigate their valuable collections, especially Staci Catron, Helen Matthews, Paige Adair, Gordon Jones, Sue Verhof, Diane Erdeljac, Ellen Johnston, Sara Logue, and Steven Engerrand.

Images in this volume appear courtesy of, among others, the Kenan Research Center at the Atlanta History Center (AHC); Special Collections and Archives, Georgia State University Library (GSU-L); the Manuscript, Archives and Rare Book Library, Emory University (MARBL); and the Hargrett Rare Book and Manuscript Library, University of Georgia Libraries (UGA).

—Betsy Crosby and Elaine Luxemburger

INTRODUCTION

In 1922, the city of Atlanta was hitting its stride, bringing with it the noise, traffic, and dust of rapid development. Prosperous professionals and business owners were beginning to look beyond the old downtown neighborhoods toward suburban life along the northern stretch of Peachtree Road, which offered both the peace and quiet of a semirural landscape and convenient access to the business district, four miles away.

Developers Benjamin Franklin Burdett and his son Arthur C. Burdett set out to capture this market with their new development, Brookwood Hills. Their streetcar suburb was located just north of the passenger railroad stop known as Brookwood station and just east of the Peachtree trolley line running from downtown to Buckhead. Despite this urban orientation, the developers made every effort to retain the rolling hills, woodlands, and meandering creeks from which the neighborhood was carved. In the process, they emphasized certain characteristics that architects, designers, and city planners would later recognize as the keys to an ideal community: well-built houses on small lots, sidewalks, street trees, clearly defined boundaries, a community center, and a lack of cut-through streets.

The area got its name in the 1890s from Brookwood, the country estate of social and business leaders Joseph and Emma Thompson. Their Queen Anne–style home, just south of today's Twenty-fifth Street where the Atlanta Masonic Center now stands, occupied a deep lot large enough for a collection of dairy cows, prize pigs, commercial greenhouses, and dog kennels. Others soon followed their example, and by the early 1900s the term Brookwood was shorthand for one of the most elite neighborhoods in Atlanta, with stately homes stretching from the intersection of West Peachtree Street to today's Huntington Road.

The wooded land beyond it, which eventually became Brookwood Hills, was old-growth forest that Native Americans once traveled through on the trail between Stone Mountain and the trading village of Standing Peachtree. During the Battle of Peach Tree Creek in the Civil War, this forest presented an "almost impenetrable thicket" to the Confederates making their initial attack against Union soldiers stationed on the high ground that later became Brighton Road.

Much of this woodland was owned by two sons of Buckhead pioneer Meredith Collier: Andrew Jackson Collier and George Washington Collier. A.J. Collier had died in 1887 and "Wash" Collier in 1903, but their heirs refused to sell, frustrating developers such as B.F. Burdett who were anxious to capitalize on the march of development up Peachtree in the early 1900s.

A.J. Collier's land finally hit the market in 1912, and Burdett, along with fellow investor E.F. Chambless, snapped up 50 acres. Large residences soon dotted the frontage along Peachtree Road, including the home Burdett built for himself at 1857 Peachtree. He reserved the rear acreage, which sloped gently toward Clear Creek, for his future subdivision.

Several children in the Burdett family shared their father's passion for real estate, especially the oldest son, Arthur C. Burdett, who began working for Burdett Realty in 1910. The Burdetts finally convinced an heir of G.W. Collier to invest additional acreage in their project, allowing their subdivision to make its debut in 1922. The first phase of Brookwood Hills included Palisades Road, Huntington Road (as far as Palisades), Northwood Avenue, and Woodcrest Avenue. In 1925, the development was expanded to include the upper half of both Brighton and Camden Roads, Montclair Drive, Wakefield Drive, Parkdale Way, and the extension of Huntington Road

to Wakefield. These two development phases were added to the National Register of Historic Places as the Brookwood Hills Historic District in 1980, which was also named a Conservation District of the City of Atlanta in 1994.

The Burdett firm hired civil engineer O.F. Kauffman, who had worked on the plans for Druid Hills, an early Atlanta suburb, with famed landscape designer Frederick Law Olmsted and his sons. Instead of imposing the strict grid typical of a streetcar suburb, Kauffman designed the same rambling, curvilinear streets favored by Olmsted. B.F. Burdett, later described as "a lover of beauty and nature," insisted on planting water oaks along these streets, creating a shady canopy that drew neighbors of all ages to the sidewalks for play, exercise, and gossip. Today, more than 90 years later, these trees have become the neighborhood's most defining characteristic.

Until the city boundary was expanded in 1952, Brookwood Hills straddled the city-county line at Palisades Road, where Peachtree Street turns into Peachtree Road. In the 1925 extension of the subdivision, the developers promoted the sale of lots north of Palisades as free from city taxation, yet accessible "to every modern luxury and convenience possible only to urban dwellers." Among the conveniences were the grocery stores, pharmacies, and restaurants that were beginning to replace the stately homes along Peachtree, catering to the everyday needs of the community, much as they do today.

The houses in the first two phases of Brookwood Hills, built on narrow lots with short setbacks, were constructed in the historical revival styles popular in the 1920s, including Tudor, Georgian, Dutch Colonial, American Colonial, Mediterranean, and Bungalow. Most of these houses featured side porches, encouraging conversations with neighbors. The compactness of the neighborhood fostered relationships across generations. "I had a dozen mamas," recalled one former resident who, as a child in the late 1940s and early 1950s, had no qualms about entering a neighbor's house to get a cookie or a glass of water.

Most important to the vitality of Brookwood Hills, however, was the Burdetts' decision to create a community recreational area out of five acres lying in a deep depression in the center of the neighborhood. A natural spring was dammed to create a large swimming lake, and a smaller concrete pool and bathhouse were built alongside it. The Burdetts fenced in the area, added nightlights, and hired lifeguards. The swimming area, reserved for residents and their guests, opened to great fanfare in August 1927. Admission was 10¢.

Financial pressures during the Great Depression forced Burdett Realty to close the pool temporarily and mortgage the recreation area to Emory University. In 1939, neighbors formed the Brookwood Hills Community Club Inc., paid off the mortgage, and took over operation of the pool. Still owned and operated by the Community Club today, the pool, nearby tennis courts, and park remain beloved gathering spots for the entire neighborhood, as well as outside members. Generations of children have enjoyed the independence of walking to the pool to spend long summer days sustained only by popsicles, popcorn, and Coke.

Initial plans for Brookwood Hills, announced in March 1922 by Burdett Realty, contemplated a thoroughfare through the neighborhood connecting Peachtree Road and Piedmont Road at Rock Springs. A plat dated three months later shows that this cut-through street was abandoned in favor of the existing cul-de-sac design. Neighborhood expansions in 1938 by Everett Thomas, representing heirs of G.W. Collier, and by developers John Hall and Ralph Willis in 1961, extended Brighton and Camden Roads to their current routings, but preserved the enclave design, considered by many to be key to the neighborhood's success.

With the Seaboard Railroad tracks lying to the north, the Southern Railway tracks to the south, and the thoroughfare of Peachtree Road to the west, developers and traffic planners have long considered the woods bordering Clear Creek to the east as a prime place to make an inroad into Brookwood Hills. Threats to this border over the years, as well as other encroachment efforts, have united the community in fierce battles to preserve this pocket enclave. The Brookwood Hills Community Club has developed a reputation of being tough, vocal, and committed on zoning matters. "The city is always trying to intrude on us," said one long-term resident, "but we keep our dukes up."

Over a number of years, the Community Club succeeded in purchasing the 55-acre woodland tract bordering Clear Creek, deterring future development threats. In 2006, the City of Atlanta purchased a conservation easement for this property as part of its mandated efforts to protect the watershed of the Chattahoochee River. Part of the proceeds from that sale enabled the creation of the Brookwood Hills Nature Preserve, one of the largest contiguous urban forests in the city.

With its proximity to the heart of Atlanta, the neighborhood has attracted a number of active citizens with a diversity of talents and interests. Prominent residents over the last 90 years include Trust Company of Georgia presidents Robert Strickland Sr. (1937–1946) and his son Robert Strickland Jr. (1976–1990); Pres. Franklin D. Roosevelt's director of defense housing, Charles F. Palmer; the first female landscape architect in Georgia, Edith Henderson; pioneering women's rights lawyer Margie Pitts Hames; and nationally renowned choral director Robert Shaw. More recently, the neighborhood has been home to best-selling authors Pat Conroy and Kathryn Stockett, HGTV designer Vern Yip, film and television actor Ed Helms, concert violist Jennifer Stumm, and Linton Hopkins, 2010 James Beard Best Chef for the Southeast.

More than nine decades after its founding, Brookwood Hills continues to function as a walkable community where the natural and built environments exist on a human scale. A small town thrives at the crossroads of Atlanta's famous Peachtree Street and two federal highways, in a green oasis where neighbors volunteer, children play outdoors, and generations come together to honor old traditions and create new ones.

—Betsy Crosby

One

Out of the Wilderness

The 1800s

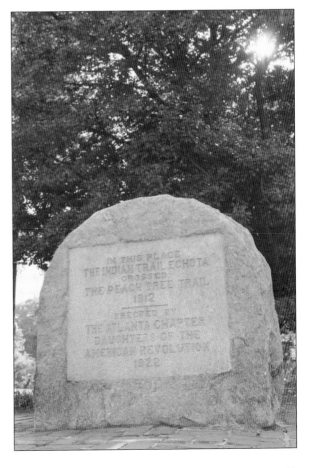

In the early 1800s, Native Americans passed through the woodland that became Brookwood Hills, following a path between Rock Mountain (now Stone Mountain) and Standing Peachtree, a trading post used by both Creek and Cherokee Indians at the mouth of Peachtree Creek on the Chattahoochee River. This granite marker on Peachtree at Palisades Road, erected by the Daughters of the American Revolution in 1922, indicates where the route is believed to have intersected with a spur of the Peachtree Indian trail. (Photograph by Kem Lee.)

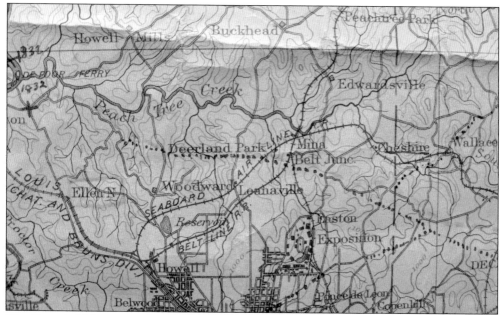

The Georgia Militia turned part of the Peachtree Indian trail into a military road after 1812. In the early 1820s, white settlers brought further traffic, eventually establishing it as Peachtree Road. This 1895 map shows Peachtree Road leading from Buckhead through a wooded area called Deerland Park, near today's Brookwood Hills. The dotted line was added by Dr. John Goff, a scholar of Native American history, to show where the Stone Mountain Indian trail once crossed Peachtree. (Courtesy of Georgia Archives, John H. Goff Collection, AC-67-064.)

Well-traveled Peachtree Creek was on the frontier between the Creek and Cherokee Indian nations. Today, the waterway skirts the northeast boundary of Brookwood Hills, at the point where it intersects with its tributary Clear Creek. As a boy in the 1940s, former neighborhood resident Stewart R. Roberts, MD, explored Peachtree Creek's banks, discovering Native American pottery shards and flint arrowheads. (Courtesy of AHC.)

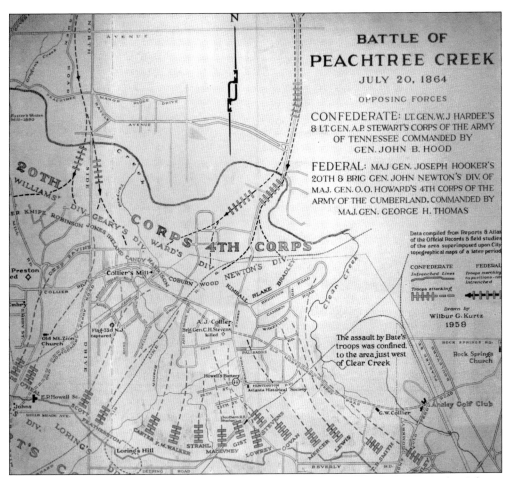

The Battle of Peach Tree Creek, on July 20, 1864, was the first of three encounters in the Atlanta Campaign during the Civil War. Union forces on the north stretched from today's Brighton Road on the east (Newton's Division) to Howell Mill Road on the west. Roughly 20,000 Confederate troops were massed about a mile to the south, their eastern flank stretching across what is now Beverly Road to the northern edge of Piedmont Park. Between the two forces lay a ravine that would become the corridor for Interstate 85. Gen. John B. Hood, who assumed command of the Confederate forces after Gen. Joseph Johnston's sudden removal, hoped to surprise the Union soldiers with an assault scheduled for 1:00 p.m. Delays ensued when he ordered a repositioning of troops, and, by the time the battle began at 4:00 p.m., the Union forces had become partially entrenched. (Courtesy of AHC.)

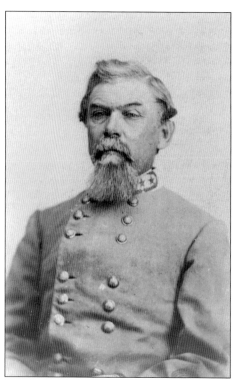

Lt. Gen. William Hardee commanded the eastern corps of the Confederate troops. A stickler for protocol, Hardee's insistence on following General Hood's orders regarding positioning of troops rather than following his on-the-ground instincts led many to blame him for losing the battle. His well-known resentment over Hood receiving the coveted command position could have played a role, perhaps making him cautious about superimposing his own judgment. (Courtesy of the Library of Congress.)

The Confederates erected the palisades seen below north of Atlanta in an effort to defend the city. Fortifications such as these, however, would have been far to the rear of the action. Although part of the Confederate assault crossed today's Palisades Road, it is unlikely that the advancing Confederates would have had the opportunity to create such entrenchments while charging through the woodland underbrush that covered Brookwood Hills at that time. (Courtesy of the Library of Congress.)

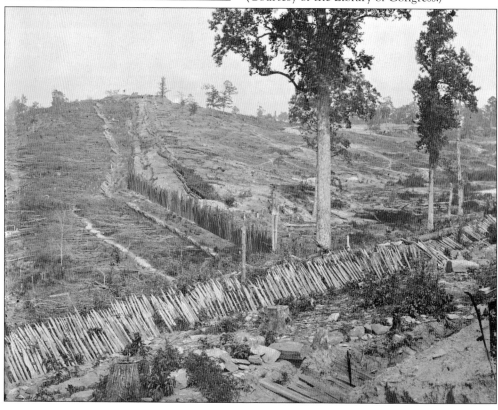

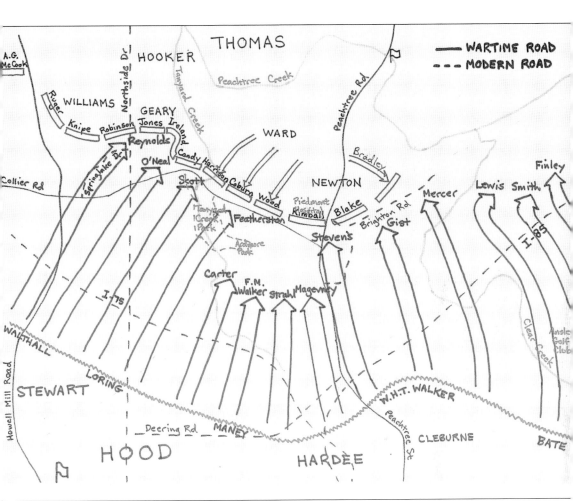

Hood's plan was for the battle to take place in an east-to-west sweep, with Maj. Gen. William Bate's division setting off a chain reaction by advancing first. His troops found themselves in what the official records later called an "almost impenetrable thicket," stumbling through the valley of Clear Creek near the current-day "new" Camden Road in a blind attempt to make contact with the Union lines. Meanwhile, Maj. Gen. William Walker's brigades charged forward along Peachtree—immense brown and gray masses of screaming rebels emerging from the tree line. Union general John Newton's four cannons were posted on the hilltop position on Brighton Road. A thunderous fusillade burst forth, cutting down the Confederate soldiers "like grass before the scythe," according to a Union report. Repulsed, the rebels attacked again, then withdrew with heavy casualties as the action shifted westward along today's Collier Road. (Courtesy of Charlie Crawford, Georgia Battlefield Association.)

The 3rd Division of the Union's 20th Army Corps was slow to take its position in the center of the Federal line due to the recalcitrance of Brig. Gen. William Ward (second from left), who was described by an Indiana soldier as "the poorest excuse for a Gen'l I ever saw." His delay created a gap at the line near Tanyard Creek. Quick action by his subordinates, Col. Benjamin Harrison (far left) and Col. Charles Coburn (far right), saved the day. (Courtesy of the Charles Harding Cox Collection, MARBL.)

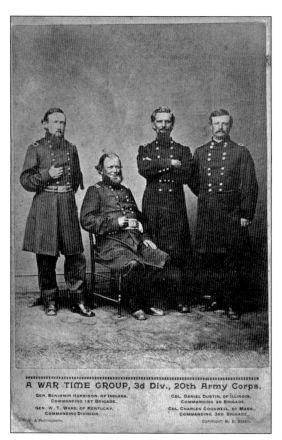

A WAR TIME GROUP, 3d Div., 20th Army Corps.

GEN. BENJAMIN HARRISON, OF INDIANA,
COMMANDING 1ST BRIGADE.
GEN. W. T. WARD, OF KENTUCKY,
COMMANDING DIVISION.

COL. DANIEL DUSTIN, OF ILLINOIS,
COMMANDING 2D BRIGADE.
COL. CHARLES COGSWELL, OF MASS.,
COMMANDING 3RD BRIGADE.

A PHOTOGRAPH. COPYRIGHT, M. B. BRADY.

Charles Harding Cox of the 70th Indiana Regiment, Ward's division, was under the command of future president Col. Benjamin Harrison, who rallied his men forward to blunt the Confederate attack up the creek. In a letter to his sister Katie dated July 23, 1864, Cox wrote that he would spare her the distressing details of the battle, but he nevertheless assured her it was "a big Thing." (Courtesy of the Charles Harding Cox Collection, MARBL.)

"The regiment," Cox wrote Katie, "was in the hottest part of the fight and where it was, I was also." Later, his regiment commander would recall, "Acting Adjutant Cox, beautiful as a girl, brave as a lion, rushes . . . to the hilltop, his form as he reaches the crest outlined against the sky, waves his hat exultantly, and beckons a command 'Forward!' for no voice could be heard in the uproar." According to legend, Tanyard Creek ran red with blood from the Confederate casualties in the brigades of Brig. Gen. Winfield Featherston and Brig. Gen. Thomas Scott, which lost half of the soldiers engaged in the charge against the Union center. Cox wrote, "A terrible slaughter of rebels—800 were buried on the field where the 20th Corps were engaged and 3 times that number wounded—Our hospitals contained twice as many rebel wounded as of our men." (Courtesy of the Charles Harding Cox Collection, MARBL.)

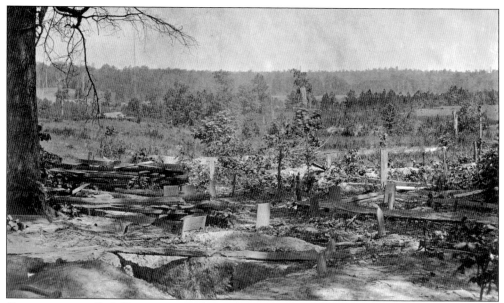

One veteran recalled, "I was in many fights, but I never saw more dead and wounded than I saw at Peach Tree Creek." The broiling July sun made hasty burials necessary the following day, and flies and maggots plagued the wounded awaiting rescue. The desolate scene in this photograph is believed to be east of Tanyard Creek, looking north from modern-day Collier Road, the area that saw the heaviest fighting. (Courtesy of UGA.)

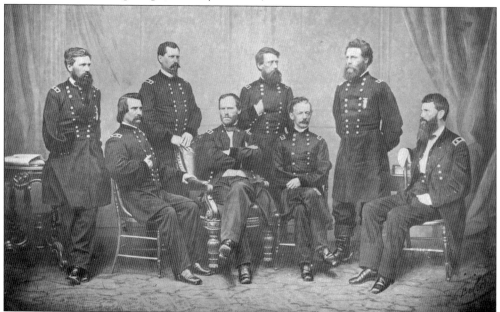

Gen. William Sherman (fourth from left) claimed that Confederate casualties numbered 4,796. According to modern historian Robert D. Jenkins, the actual number was half that amount, 2,379, compared to Union losses of 2,167. The narrow Union victory nevertheless provided the momentum for Sherman to "deliver" Atlanta in September, thereby enabling President Lincoln's reelection. Some historians consider the third week of July in 1864 to be the pivotal moment when the war was decided. (Courtesy of UGA.)

Col. Benjamin Harrison of Indiana returned from the war to accolades from the public and the press, who began calling him the "Hero of Peach Tree Creek." A grandson of Pres. William Harrison, he soon sought political office, and, after serving in the US senate, he was elected president in 1888. His great-great-granddaughter Mary Harrison "Button" Cook later raised her family in Brookwood Hills, near the battlefield that launched his political career. (Courtesy of the Library of Congress.)

In 1919, Confederate veteran Sidney L. Hilton (below, seated center, black jacket) of Tallapoosa, Georgia, posed with his family for this photograph. Hilton lost his right arm in a skirmish during the Battle of Peach Tree Creek, but survived to become the patriarch of this large clan. The timing of this family reunion, nearly 55 years to the day after the battle, suggests that all present had heard the tale of that momentous fight. (Courtesy of Georgia Archives, Virtual Georgia, VRG206.)

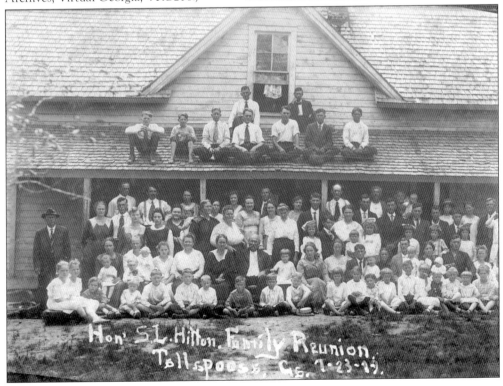

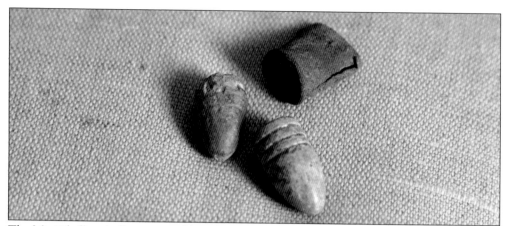

The Minié ball, or bullet, invented by Claude Etienne Minié in 1847, revolutionized war tactics because of its great range. Toward the end of the war, a new technology came into use: the repeating rifle. Although not officially issued, some Union soldiers used personal funds to purchase Henry repeating rifles. Cartridges from these rifles, as well as Minié balls, have been found in Brookwood Hills in recent years. (Photograph by Kem Lee.)

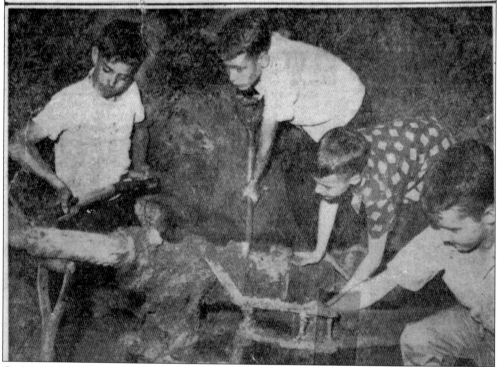

8-B **The Atlanta Journal** ★ THE ATLANTA CONSTITUTION SUNDAY, MAY 6, 1951

On May 6, 1951, this newspaper story reported that four boys from Brookwood Hills had discovered a Civil War ammunition carrier, or limber, on the north bank of Clear Creek. Pictured from left to right, Curtis Miles, Lester Shepherd, John Wolfe, and Larry Willoughby eventually sold their discovery to the Atlanta Art Museum for $20. Shepherd recalled over 60 years later that this grand sum "bought a lot of toy soldiers." (Courtesy of Lester Shepherd; reprinted with permission of the *Atlanta Journal-Constitution*.)

Two

THE MOST FASHIONABLE SUBURB

1890s–1920

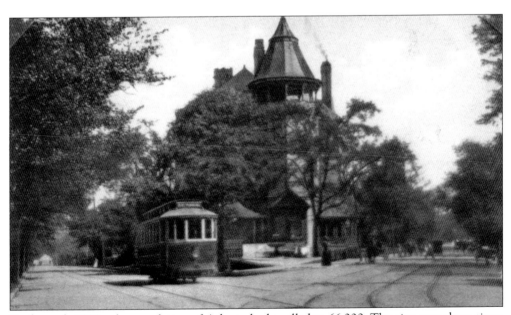

By the early 1890s, the population of Atlanta had swelled to 66,000. The city, now three times the size it had been shortly before the Battle of Atlanta, was increasingly plagued by the noise and dust of urban life. The introduction in 1889 of the electric-powered trolley, seen here plying the stretch of Peachtree at the intersection of West Peachtree Street, fostered suburban development outside the city's strict grid. (Courtesy of AHC.)

George Washington Collier (center), pictured in 1897 with fellow Atlanta pioneers John J. Thrasher (left) and George Adair, was an eccentric character. He married for the first time at age 60, to 18-year-old Lesbia Ann Cornet, who bore him eight children. Throughout his life, he bought land as it came on the market, adding to the land given to him by his father, Meredith Collier, an early settler. He had numerous holdings downtown and owned over 400 acres in Township 17, Fulton County, including Land Lots 103, 104, 105, 109, and 110, part of the Peachtree District (below), covering today's Ansley Park and Brookwood Hills. Seen as holding the key to the northern development of Peachtree Road, he refused offers to sell. When he died in 1903 at almost 90 years old, his heirs squabbled over the management of his estate while anxious developers looked on. (Both courtesy of AHC.)

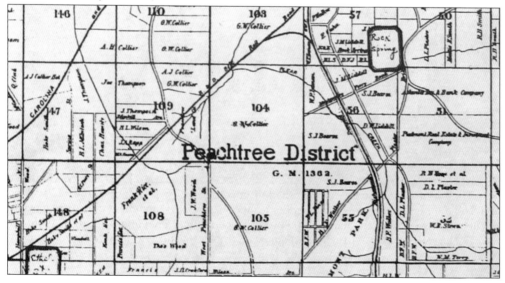

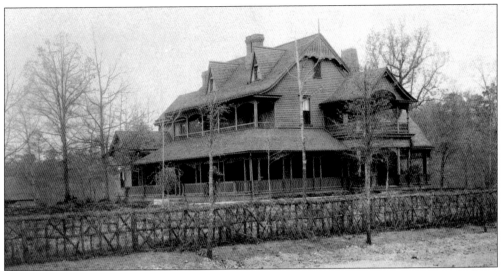

"Brookwood Where Roses Bloom, is a Real Farm on the City's Edge," gushed an 1899 *Atlanta Constitution* headline. Brookwood, a Queen Anne–style house built in 1895, was the summer retreat of society leaders Joseph and Emma Thompson. Located just north of today's Brookwood train station, the Thompsons' deep lot supported 25 Jersey cows, 100 Berkshire pigs, breeding kennels for beagles and Great Danes, and greenhouses for flowers and fruit. (Courtesy of AHC.)

The Thompsons entertained distinguished visitors such as US presidents Grover Cleveland and William McKinley at their summer home (above), inspiring prominent citizens to move to the area that soon bore the name "Brookwood." Upon Emma Thompson's death in 1908, the *Atlanta Journal* called her "virtually the founder of Brookwood, now the most fashionable suburb of Atlanta . . . She built the first country home there and her example was speedily followed." (Courtesy of AHC.)

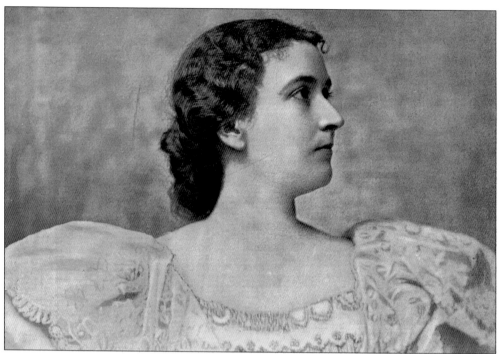

At the age of 31, Emma Mims Thompson (above) was named president of the Board of Lady Managers of the Woman's Building (below) for the 1895 Cotton States and International Exposition, held at present-day Piedmont Park. The 1896 official history of the exposition praised Thompson as a noted beauty and belle but also credited her brilliance and cultural refinement. Her contemporary, T.C. De Leon, later remembered her as one who "entered society with *verve*; winning friends easily by her fund of grace and quickness, losing them sometimes by too much *sauce Tartare* upon her tongue." (Both courtesy of AHC.)

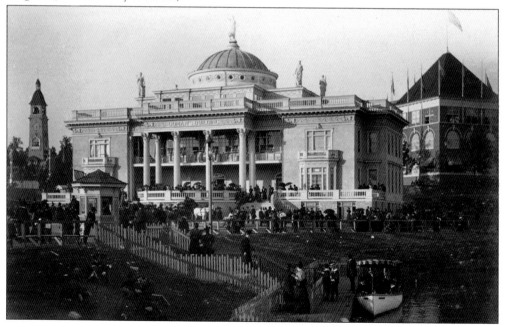

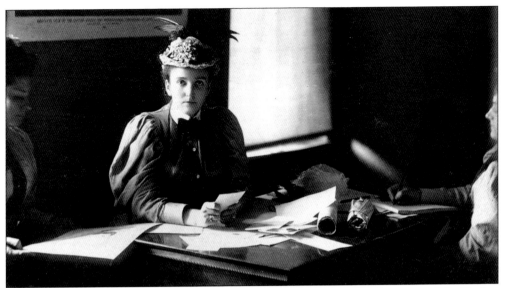

Emma Thompson's management of the Woman's Building won wide admiration. Like Booker T. Washington, who advocated the compromise of racial segregation rather than confrontation, Thompson, seen here in her office, assured the public that a woman "was neither the antagonist nor the rival of man, but his co-worker and help-meet." As authors Staci Catron and Susan Neill noted in *Women in Atlanta*, the exposition, nevertheless, gave momentum to various women's organizations. (Courtesy of AHC.)

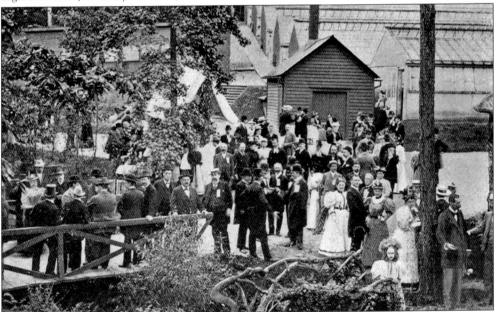

Similar to the 1996 Atlanta Olympics a century later, the 1895 Cotton States and International Exposition was intended to raise Atlanta's profile both nationally and internationally. As part of a campaign to promote the upcoming exposition, Joseph and Emma Thompson hosted this celebrated lawn party in May 1895 in honor of visiting members of the Washington press corps. Guests toured the estate's greenhouses, which were used by Joseph Thompson in his Brookwood Floral Company business venture. (Courtesy of Sharon Foster Jones.)

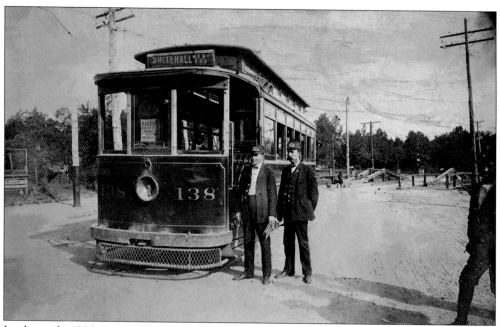

In the early 1900s, two streetcar conductors on the Whitehall line pose at their final stop, Brookwood. The trip took 40 minutes from the city center. Behind them is the Brookwood bridge, spanning the ravine where Interstates 85 and 75 now meet to form the Brookwood Interchange. In 1909, the bridge marked the start for bicycle and motorcycle races to Buckhead, which were held along this rural stretch of Peachtree Road. (Courtesy of Georgia Archives, Vanishing Georgia, fra027.)

In 1901, attorney Jack J. Spalding, the founder of the law firm King & Spalding, purchased his country home, Deerland, just north of the Brookwood area. Spalding hoped to remove his two sons from cockfighting and other city influences that were plaguing their old Fourteenth Street neighborhood. Thanks in part to his efforts, however, his client the Georgia Railway & Electric Company extended the trolley tracks to Buckhead in 1907, bringing the city to his doorstep. (Courtesy of AHC.)

Elizabeth Hughes Spalding was the childhood sweetheart of Jack Spalding, marrying him in their hometown of Morganfield, Kentucky, in 1875. In this 1904 photograph, she stands in front of their home, Deerland, where Piedmont Hospital is now located. Spalding's law firm, King & Spalding, was one of the most influential in Atlanta, as it is today, allowing him the means to purchase the exciting new "horseless carriage" behind his wife. (Courtesy of Van Schroder Waddy.)

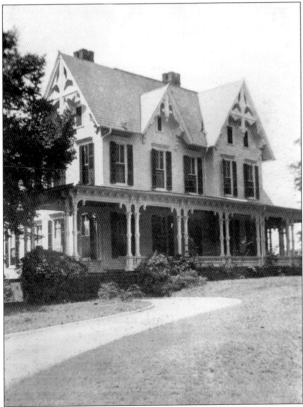

Deerland was originally built in 1873 by Col. Reuben Arnold, whose son, Reuben R. Arnold, later represented Leo Frank in his 1913 murder trial. The 11-acre estate, with chickens, guineas, and a dairy cow, brought Jack Spalding an opportunity to relive, through his two sons, his rural upbringing. The boys worked in their spare time on the scuppernong arbor and the orchard, and delivered fruit and peas from the one-acre garden to the grocer. (Courtesy of Van Schroder Waddy.)

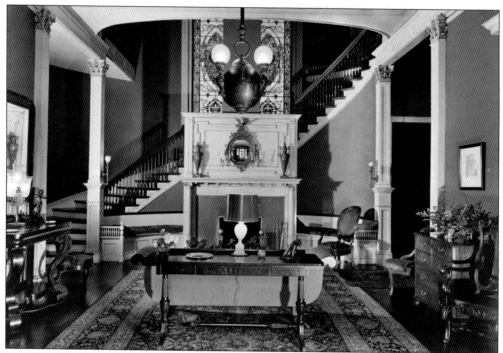

The Brookwood area was commonly understood to stretch from the intersection of Peachtree and West Peachtree Streets to what would later become Huntington Road. Among the prominent residents were banker Thomas R. Sawtell (1600 Peachtree) and Eugene R. Black (1614 Peachtree), the son-in-law of Henry Grady. Both built two-story, columned homes that sat back from the street. The photograph above, showing the interior of the Sawtell home, was taken in 1953 by later residents. Shortly after the photograph was taken, the home was replaced by the Retail Credit Company (Equifax), and it is now home to the Atlanta campus of the Savannah College of Art and Design. Below, at 1640 Peachtree Street, just south of the Brookwood bridge, was the imposing home of Trust Company of Georgia founder Clifford L. Anderson. The 1895 estate, called La Colina, or "The Hill," became Washington Seminary for Girls in 1913. It was replaced in 1954 by the Riviera Motel. (Both courtesy of GSU-L.)

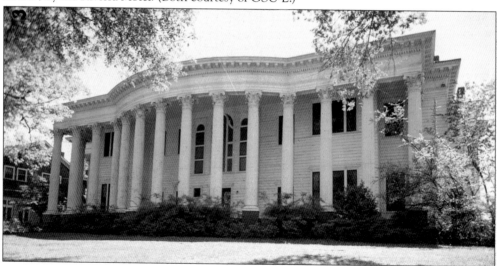

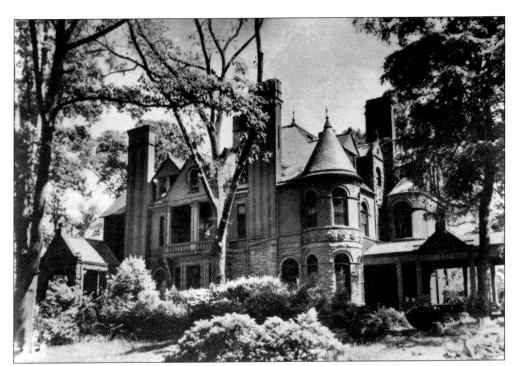

At 1611 Peachtree Street, just north of where The Temple stands today, was the 20-room Romanesque Revival residence of Mrs. William A. Speer (above). Built in 1887 by her father, John Silvey, it originally stood on the corner of Spring and Marietta Streets. When development overtook that area, Katie Speer had the house painstakingly dismantled and rebuilt in 1903 on this site, where it became known as Speer Castle. With the construction of Peachtree Christian Church (1928) and The Temple (1931), designed by Philip Shutze for the Hebrew Benevolent Congregation, Brookwood's grand residences began to be replaced by commercial structures. The image at right shows the garden statuary that was auctioned off before Speer Castle was demolished for the construction of an office building in 1950. (Above, courtesy of AHC; right, courtesy of GSU-L, reprinted with permission of the *Atlanta Journal-Constitution*.)

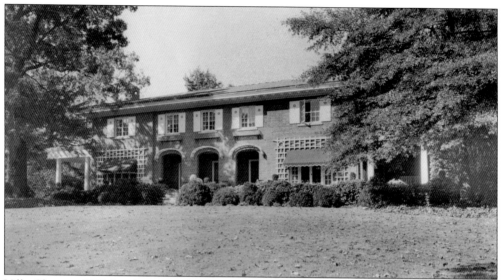

Villa Clare, at 2020 Peachtree Road, was the home of J.J. Haverty, the founder of the Haverty Furniture Company. His good friend Jack Spalding had encouraged him to buy the six-acre lot, just north of Spalding's Deerland. Designed by Edward E. Dougherty and completed in 1916, the house was named both for Haverty's wife, Clara, and for County Clare, Ireland. Today, the Shepherd Center for spinal cord and brain injury rehabilitation is on the site. (Courtesy of the Haverty family.)

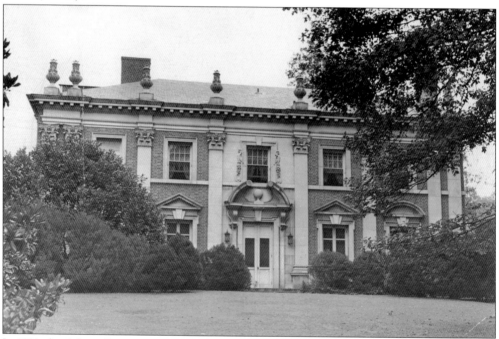

In 1921, the *Atlanta Constitution* reported the sale of a Peachtree Road lot by G.W. Collier's heirs to Dr. Willis Jones for the then-stupendous sum of $25,000. This elegant mansion, designed by Neel Reid and constructed for another $60,000, was built at the corner of today's Huntington Road. It later became the home of the Atlanta Historical Society. In 1969, the house was purchased by a private owner and moved to 520 West Paces Ferry Road. (Courtesy of AHC.)

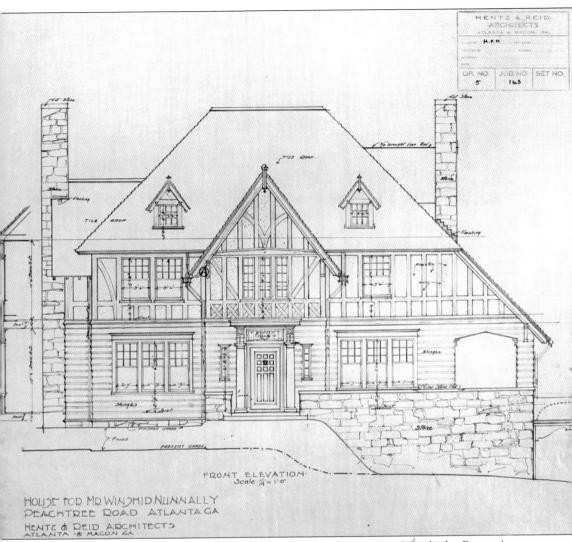

FRONT ELEVATION
Scale ¼" = 1'0"

HOUSE FOR MR WINSHIP NUNNALLY
PEACHTREE ROAD ATLANTA GA
HENTZ & REID ARCHITECTS
ATLANTA & MACON GA.

Prior to World War I, Macon native Neel Reid studied architecture at L'École des Beaux-Arts in Paris, returning to Atlanta in 1909 to establish the firm Hentz & Reid (later Hentz, Reid & Adler), where he was the principal designer. Reid designed seven homes in the Brookwood vicinity. This large Tudor Revival home was a commission completed for Winship Nunnally in 1912. It stood just south of Twenty-fifth Street on part of the lot once owned by Joseph Thompson. Here, elaborate half-timbering within a steep gable emphasizes the front entrance, the focus of many of Reid's designs. His broad talents were on display in the variety of architectural styles found in the homes he designed in this area. Many important Atlanta architects, including Philip Shutze, worked with Reid before his death in 1926. (Courtesy of AHC.)

Between 1910 and 1925, several significant residences were built in the Brookwood area, an elegant stretch of Peachtree Street that the *Atlanta Journal* compared to Brookline, near Boston, and Riverside Drive, in New York. The opening of Southern Railway's Brookwood station in 1918, however, made the area so popular that it quickly became less exclusive. In 1919, the Elmwood Apartments, now known as the Brookwood Exchange, were built on part of the Joseph Thompson property. Huntington Arms Apartments, at Peachtree Street and Huntington Road, and the Mayflower Apartments, at Peachtree and Twenty-eighth Street, were in place by 1931. The Charles Freeman house, at 1745 Peachtree (above), eventually became the Atlanta Jewish Community Center, and the Emma Kirk house (below), on the southeast corner of Palisades Road and Peachtree Street, was torn down for the construction of an office building in the early 1960s. (Both courtesy of GSU-L.)

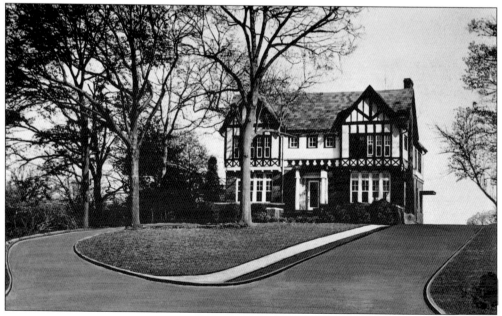

Three

ANNOUNCING BROOKWOOD HILLS

1920s–1970s

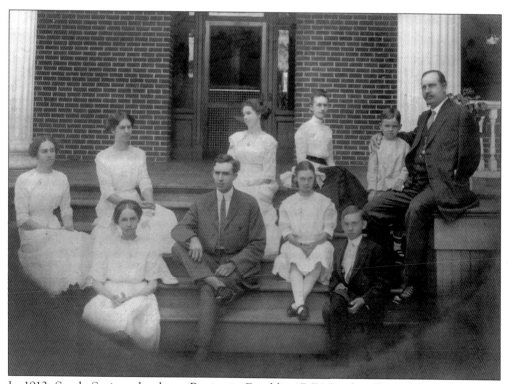

In 1912, Sandy Springs developer Benjamin Franklin "B.F." Burdett (far right) made his first investment in the Brookwood area with a purchase of 50 acres from the A.J. Collier estate. Seen here with his family on the porch of his Sandy Springs home around 1916, he soon relocated to Atlanta to oversee his new holdings on Peachtree. His oldest son, Arthur (center), worked with him at Burdett Realty to develop Brookwood Hills. (Courtesy of Jenny Miles Paulsen.)

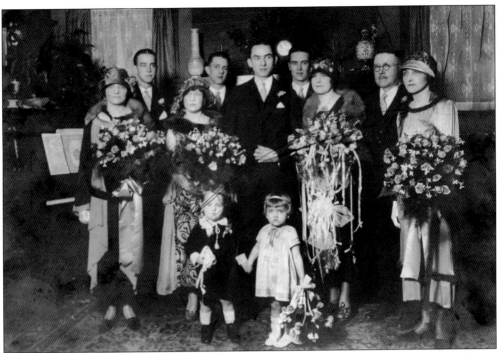

The photograph above was taken in 1924 at the wedding of B.F. Burdett's second-oldest son, Lawrence, to Katherine Comer. Lawrence's nephew Arthur Burdett Jr. (front, left), who would later lead the family firm, served as ring-bearer. Lawrence became the spokesman for Burdett Realty, and his eloquence and enthusiasm matched the mood of the booming 1920s. Eventually, all three brothers, three brothers-in-law, and one sister were associated with the company, and several bought homes in the subdivision built behind their parents' home, 1857 Peachtree Road. (Courtesy of Claire Burdett Simpson.)

This advertisement appeared in the *Atlanta Constitution* on May 7, 1922, helping to kick off the initial sales campaign for Brookwood Hills. The advertisement promised that the wooded landscape, when completely developed, "will constitute one of the most desirable residential sections in Atlanta." The developers sought to take advantage of the property's proximity to the exclusive Brookwood area, describing it as being within "a stone's throw." (Reprinted with permission of the *Atlanta Journal-Constitution*.)

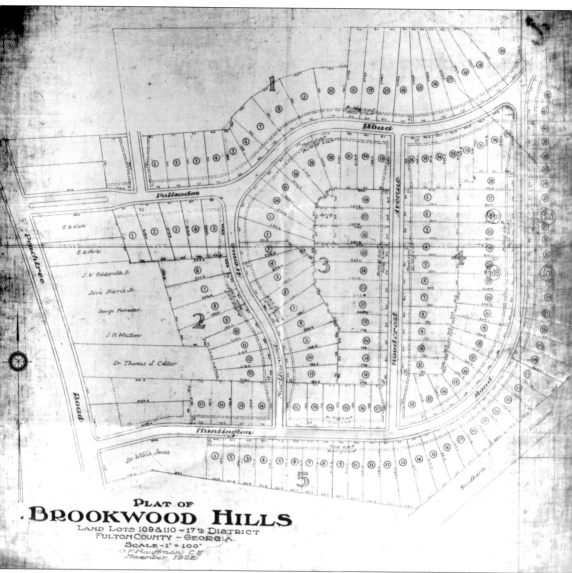

PLAT OF
BROOKWOOD HILLS
LAND LOTS 109 & 110 – 17th DISTRICT
FULTON COUNTY – GEORGIA.
SCALE – 1" = 100'
O. F. Kauffman C.E.
November 1922.

The Burdetts, acutely aware of earlier Atlanta developments, chose to follow the lead of the Druid Hills Company by hiring civil engineer O.F. Kauffman, who had worked on the plan for Druid Hills, made by Frederick Law Olmsted and his sons. Kauffman carried Olmsted's curvilinear street designs to Brookwood Hills, following the contours of the land as it sloped from the ridge of Peachtree Road to the bed of Clear Creek. The first phase of Brookwood Hills was developed between 1922 and 1924, and included Palisades, Huntington, Northwood, and Woodcrest. Sales were brisk from the start, due partly to the development's convenient location on the streetcar line, four miles from the city center. As Lawrence Burdett told the newspaper, the development was "accessible to parks, churches, schools and everything that goes to make life pleasant for modern men and women." (Courtesy of AHC.)

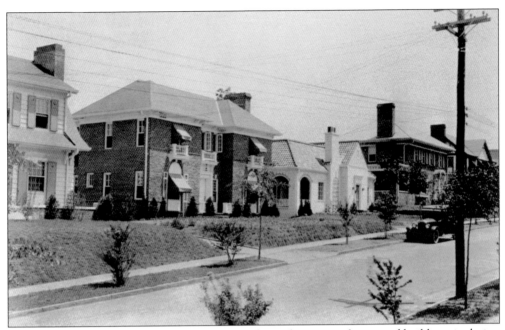

The original deeds allowed each homeowner to choose his own architect and builder, stipulating that houses have a minimum investment value of $7,500–$10,000, depending on lot location. With the historic revival movement in full swing, the result was a mix of Tudor, Georgian, Mediterranean, Dutch Colonial, American Colonial, and Bungalow-style homes. The homes were carefully crafted, with many boasting such architectural details as columns, lintels, arches, and half-timbering. (Courtesy of AHC.)

"Mr. B.F.," as he was affectionately known, shown here with his wife, Jennie, was a nature lover and a gardener despite the loss of his left arm early in life. Aided by his helpers, known as Pink and Green, he planted water oaks between the sidewalks and the streets, interspersed with two crepe myrtles. His foresight in instilling this street landscaping was unusual for the time and created the shady setting for which Brookwood Hills later became known. (Courtesy of Jenny Miles Paulsen.)

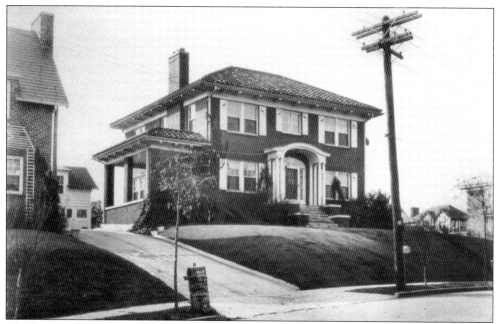

The deeds prohibited keeping or maintaining swine, but did permit other livestock, such as a single cow "for private family use." Former resident William A. Parker Jr. recalled his family keeping a milk cow and chickens behind their home, at 61 Brighton Road, to supplement their rations during World War II. Many wartime residents also had Victory gardens, including enthusiastic gardeners Edwin and Mildred Camp, who built the home at 115 Palisades Road, seen here. (Courtesy of Bruce D. Wanamaker.)

In 1925, Mattison and Florence Henderson posed for this photograph at their new Huntington Road home with their daughter Virginia and a family friend. Mr. Henderson owned one of the first rental car agencies in Atlanta. The stock market crash of 1929 caused financial difficulties for the Hendersons, leading to the closure of his business and the sale of this home. His fortunes improved, and he eventually returned to the neighborhood (See page 76). (Courtesy of Genna Brown.)

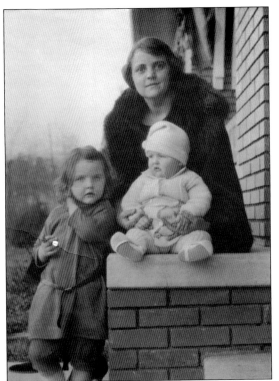

In the 1922 photograph at left, Sadie Burdett, the wife of Arthur C. Burdett, poses with her daughter Polly and baby Arthur Jr., who was called Billy. The young family lived briefly at 10 Palisades Road, the first home in the development, which was constructed on the back half of the Peachtree Road lot owned by Arthur Sr.'s parents. By 1925, the couple had moved to 21 Northwood Avenue, next to Arthur's sister Lenna and her husband, L.A. "Mac" McKinley, who resided at 23 Northwood. These homes may have been built on speculation by Burdett Realty for eventual sale, but, by 1926, Sadie and Arthur had settled into their commodious Tudor home at 70 Palisades Road, where they lived for many years. Arthur Sr., seen below with Sadie in 1953, had a leading role in the family business and became head of the firm after his father's death in 1935. (Left, courtesy of Jenny Miles Paulsen; below, courtesy of Claire Burdett Simpson.)

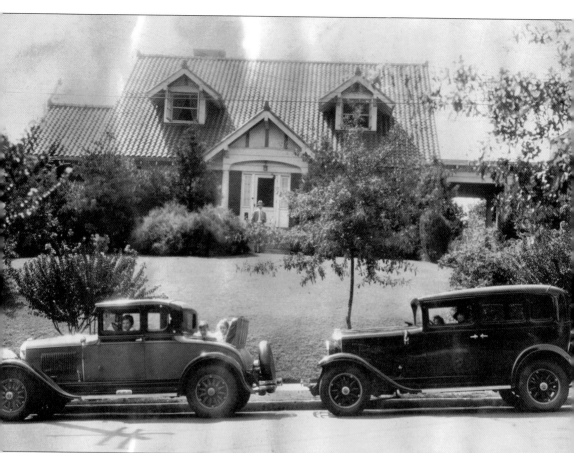

Dr. Mark P. Pentecost built this Mediterranean-style home in 1923. The exotic terra-cotta roof, popular in the 1920s, appealed to a sophisticated post–World War I generation that had been exposed to European styles through movies, print, and travel. Such architectural elements allowed one to envision owning a "Castle in Spain" like the Huntington Road bungalow on the next page, advertised in a 1923 issue of *City Builder* magazine. Dr. Pentecost's two cars, an REO roadster with a rumble seat and an REO sedan, was an extravagance in the 1920s, when most families owned only one automobile. The family justified it, however, because of the many house calls Dr. Pentecost was required to make in his busy medical practice. (Courtesy of Martha M. Pentecost.)

Along with architectural diversity, another selling point of the neighborhood was the quality of construction by builders such as H.W. Nicholes, Gilbert Beers, and Joe Walker. The majority of the houses were built of brick, creating "a wealth of beauty, safety and permanence," as this 1923 advertisement proclaims. A significant number of neighborhood homes dating from the 1920s still bear their original tile or slate roofs. The strong roofs and structural beams protected neighborhood residents from bodily harm during 1995's Hurricane Opal, which uprooted dozens of mature oaks and left them leaning against chimneys and ridge beams. (Courtesy of AHC.)

The original deeds prohibited selling, renting, or otherwise disposing of the property to persons of African descent, a clause common in the era of racial segregation. In the 1920s and 1930s, many residents had live-in domestic servants whose garage or basement apartments offered sparse amenities such as cold water taps and potbellied stoves for heat. At right, Beatrice, the Gann family cook, peaks at Archie Gann Jr. and his sister Clara in 1938 from her domain, the kitchen door. The playgroup or children's birthday party seen below in the late 1930s shows the pervasiveness of uniformed maids at the time. By the 1940s, there were few live-in servants, and daily domestic help usually arrived by trolley or bus. Even then, one longtime resident recalled, a typical workweek was six and a half days a week from 7:00 a.m. to 7:00 p.m., for which the average weekly salary was about $7. (Both courtesy of Clara Mont-Claire O'Shea.)

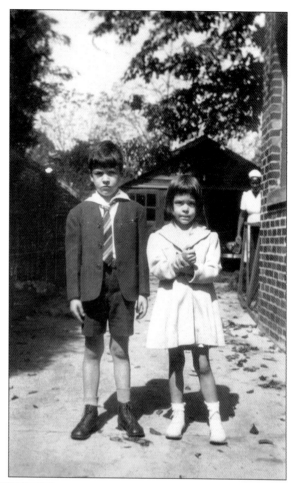

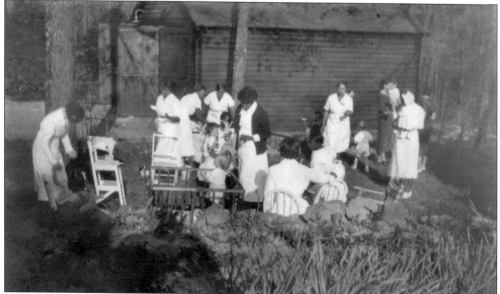

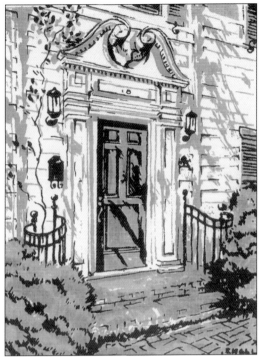

The front entrance of 18 Palisades Road proved so compelling that it became the subject of this 1940s watercolor sketch. The scrolled pediment and engaged columns on the door surround were typical American Colonial details of the historic revival period of the 1920s. This home is believed to have been designed by the firm of Burge & Stevens, the architects of the Capital City Club in Brookhaven. (Courtesy of Terry Currie Banta.)

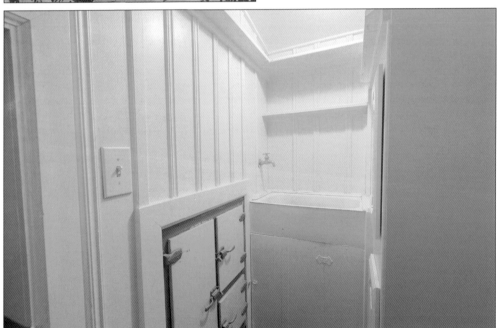

One unusual feature of 18 Palisades Road was its private speakeasy, including the bar, sink, and refrigerator shown here hidden behind a swinging bookcase in the basement. Hollis Rawson Easley, who grew up nearby at 37 Palisades in the early 1930s, remembers a "clandestine figure" coming to the back door after dark. "It was the bootlegger, bringing prohibitive liquor for the following months. We were never allowed to see or mention him!" (Photograph by Douglas K. Sindelar; courtesy of Christy Harris.)

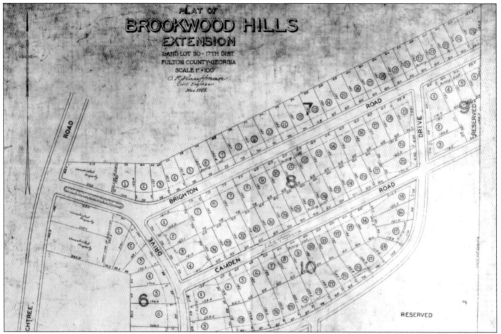

In September 1925, Burdett Realty announced the opening of lots on Brighton, Camden, Wakefield, and Montclair. The firm, by then a corporation, had bought an additional 50 acres from the G.W. Collier estate and others in Land Lots 103 and 110 to create this new extension. A selling point for this section, including Brighton Road (below), was its location outside the city limits, freeing the owners from city taxation yet permitting them, in the words of Lawrence Burdett, "to enjoy every modern luxury and convenience possible to urban dwellers." A 1922 newspaper article discussing early development plans proposed a thoroughfare through the neighborhood, connecting Peachtree Road with Piedmont Road at Rock Springs. By 1925, however, the company recognized the merits of the enclave design and promoted the development's secluded nature, citing its "slightly rolling hillsides and pretty valleys." (Above, courtesy of AHC; below, courtesy of the Strickland family.)

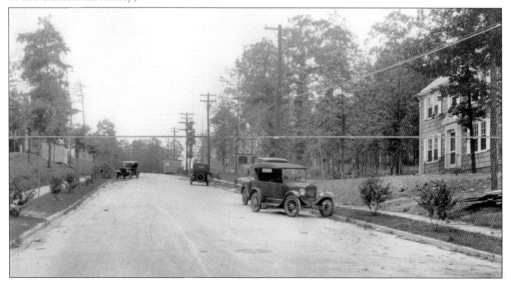

Little Marion Moise is seen here in 1928 on the bricks that would form her home, at 101 Brighton Road. Her father, attorney E. Warren Moise, would often say that the house was built on Coca-Cola, having sold his stock to pay for construction costs. The statement would send young Marion, named for her mother, looking for bottles under the foundation. An only child, she had many playmates among the young children on Brighton Road. (Courtesy of Karen Klare.)

The architecture firm of Mayre, Alger & Vinour designed the one-story house of Warren and Marion Moise in accordance with Mrs. Moise's preferences for single-floor living. The large basement included living quarters for the cook, Mary Massey, who served three meals a day in the formal dining room. Architect P. Thornton Mayre was known for several notable buildings in Atlanta, including the Fox Theater, St. Luke's Episcopal Church, and the Randolph-Lucas House. (Courtesy of Karen Klare.)

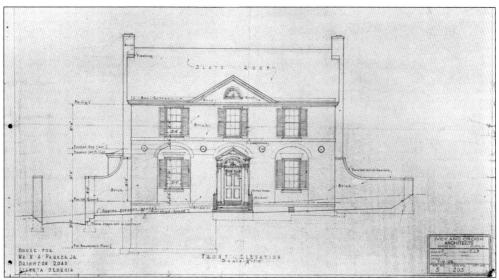

This house, at 61 Brighton Road, was designed by architects Ed Ivey and Lewis "Buck" Crook and built for the William A. Parker family in 1928. Both Ivey and Crook were draftsmen for renowned architect Neel Reid before founding their own firm in 1923. Below, in 1932, young William Parker Jr. stands in front of the elaborate doorway, the focus of the home's design. The paneled archway is surmounted by a triangular pediment with columns, and all is fitted within the center-arched niche. Other architectural details include a glazed fanlight and four limestone medallions across the facade, resembling earthquake ties seen on old structures in Charleston, South Carolina. Ivey and Crook are believed to have designed at least two homes on Palisades Road as well. Other renowned neighborhood architects were Pringle & Smith (35 Palisades Road) and Frazier & Bodin (67 Brighton Road). (Above, courtesy of Matt and Anna Cate Little; below, courtesy of William A. Parker Jr.)

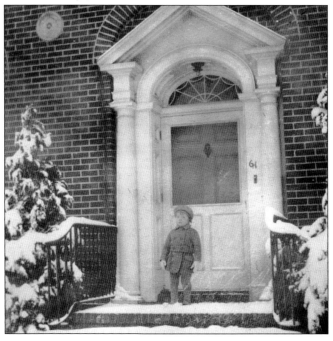

The Burdett Realty Company experienced a banner year in 1926, leading Arthur Burdett to build this Tudor home above on a large hilltop lot on Palisades Road. The house overlooked a gully and a natural spring reserved for recreational use. Arthur's brother Lawrence predicted that with the growth of Atlanta northward, "nothing short of oblivion" would cause the Brookwood Hills area to fail to enhance in value. Such confidence led Burdett Realty to invest nearly $50,000, including land costs, in a pool and a park. The new recreational area opened in August 1927. Arthur Burdett Jr. and his son Arthur Burdett III, known as Clint, are seen below in front of the garage and servants' quarters to the rear of the house, which were enlarged in the early postwar years for Arthur Jr., a veteran, and his wife, Doris. In the 1960s, Arthur Jr., a principal of Burdett Realty, became president of the Atlanta Real Estate Board. (Both courtesy of Claire Burdett Simpson.)

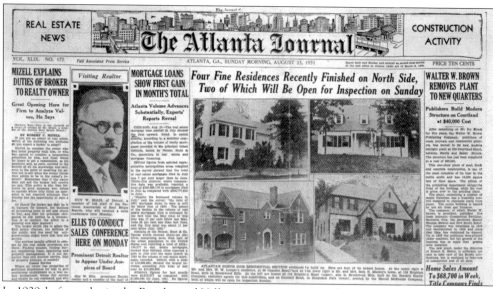

In 1929, before sales in the Brookwood Hills extension were completed, the stock market crashed. Although Burdett Realty continued to advertise in the newspaper for the next two years, slow sales forced the mortgaging of 28 unsold parcels to Emory University on October 16, 1931. The Depression also led the Lyngars, the owners of 66 Camden Road (house in the upper-right corner of the newspaper image), to rent out their home for several years. (Courtesy of Claire Burdett Simpson; reprinted with permission of the *Atlanta Journal-Constitution*.)

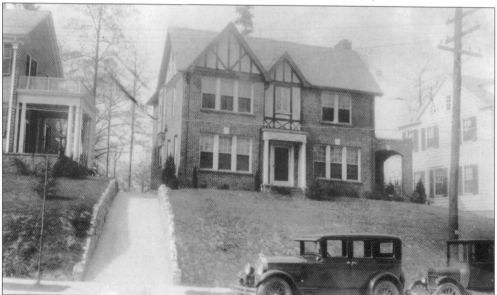

The Great Depression arrived two years after John and Jeanette Olden built this home at 34 Brighton Road. John, the general manager for roofing and insulation manufacturer Johns-Manville, then saw the construction business wither. Jeannette Olden later told her granddaughter Marie how she would cry into her pillow at night, worrying about their $17,000 mortgage. Luckily, the Oldens were able to hang on, enjoying their home for several more decades until 1988, when Jeanette, at age 98, decided to sell "before [her] age got in the way." (Courtesy of AHC, Brookwood Hills Legacy file.)

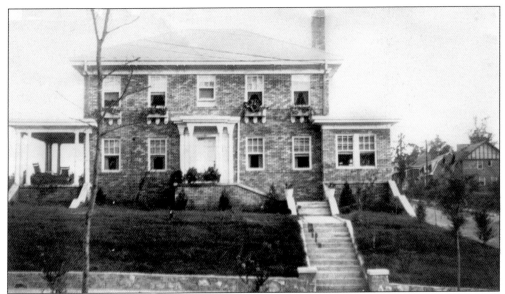

Open side porches were typical of many homes built in Brookwood Hills in the 1920s, including this house, at 75 Palisades Road. In the 1930s, screening became a practical home improvement. The temperate weather led many residents to spend the cool evening hours outdoors, visiting with their neighbors as they passed by. Former Brighton Road resident Jack Olden recalled sleeping on his home's side porch on "many a night." (Courtesy of Cissie and Frank White.)

Before the street trees grew large enough to provide a shade canopy, many homes added awnings as a shield from the intense summer sun. Another cooling strategy was the installation of an attic fan, leading Edwin and Mildred Camp to invite neighbors to a house-cooling welcoming "Fanny." The tongue-in-cheek "Carte de Jour" offered peanuts, popcorn, chewing gum, and Old Grand-Dad whiskey. "Singing," the invitation read, "will be well in order." (Photograph courtesy of Dana and Mike White; invitation courtesy of Bruce D. Wanamaker.)

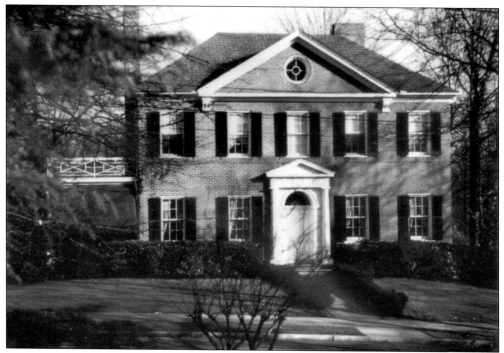

Of the many residences in the Brookwood area designed by Neel Reid of Hentz, Reid & Adler, this home, at 14 Palisades Road, is the last that remains in its original location. Built in 1922, it reflects a favorite Atlanta style: Georgian Revival. The use of symmetry and classical details shows Reid's academic awareness of, and respect for, 18th-century architecture. In the late 1940s, when air conditioning became available, owners Alice and Richard Sawtell hired James Means to enclose the original side porch and add a formal, brick-walled garden behind it. Means had worked under Neel Reid and Philip Shutze, who influenced his stylistic preferences and sense of classical proportion. The hand-rubbed heart-pine paneling he specified for this library was inspired by the woodwork in an 18th-century house in Deerfield, Massachusetts. (Both courtesy of Elaine Luxemburger.)

The third section of Brookwood Hills, an extension of Brighton and Camden Roads, was developed in 1938 by Everett Thomas on land owned by his wife and her sister, granddaughters of George Washington Collier. Although "Wash" Collier's heirs had invested with Burdett Realty in the first phase of Brookwood Hills and had sold it land for the second phase, this last development was independent of Burdett Realty, although constructed with its consent. (Courtesy of GSU-L.)

The postwar period, with its returning war veterans, brought a building boom to Atlanta. Empty lots in Brookwood Hills, including those still owned by Burdett Realty and those unsold in the Everett Thomas development, saw the construction of new homes, including 68 Wakefield Drive, seen here. The automobile age had fully arrived, and Everett Thomas chose not to include either street trees or sidewalks in his development, because "everyone had cars by then." (Courtesy of Frank D. Inman.)

In 1961, Eileen Corrigan, who was employed by the Civilian Defense Fund during the Cold War, began a renovation project at her home at 26 Woodcrest Avenue. The remodel enclosed her side porch as a den, extended the master bedroom above it, and added a model bomb shelter in the basement. The latter proved to be the most expensive room in the house and saw the most use as a practice room for her son's rock band. (Courtesy of Betsy Crosby.)

Builders John Hall and Ralph Willis developed the fourth and final section of Brookwood Hills in 1961 on a small parcel where Clear Creek and Peachtree Creek converge called Prospect Point. Once part of the Collier family holdings, the development added 28 new homes in a cul-de-sac extension of Camden Road, which became known as "New Camden." The developers included sidewalks in this section but no street trees. (Courtesy of Dr. Milton and Cookie Frank.)

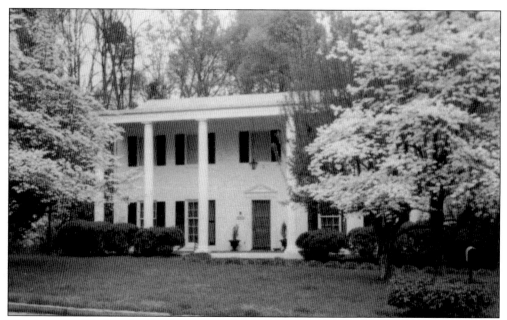

This home at 272 Camden Road was one of the earliest in the New Camden subdivision. Built in a style known as Southern Colonial, it attracted the eye of the subsequent owner, who quickly paid $10 dollars for a down payment to secure its purchase. A dead end, New Camden became the favorite playground of many Brookwood Hills children because of the lack of traffic and its proximity to Clear Creek. (Courtesy of Dr. Milton and Cookie Frank.)

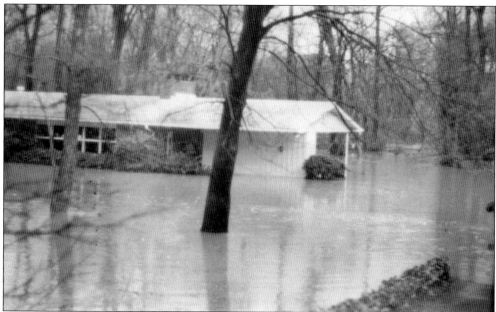

New Camden was a successful development despite being built on a marginal floodplain. In the spring of 1975, however, residents of the lower parts of Camden Road awoke to find Clear Creek's waters rising. When it happened again in 2009, many homeowners chose to raise their homes above flood level. The city's construction of a new storm water retention pond along Clear Creek helped alleviate the problem. (Courtesy of Frank and Mary Anne Chew.)

Four

BROOKWOOD HILLS GROWS UP
1920s–1960s

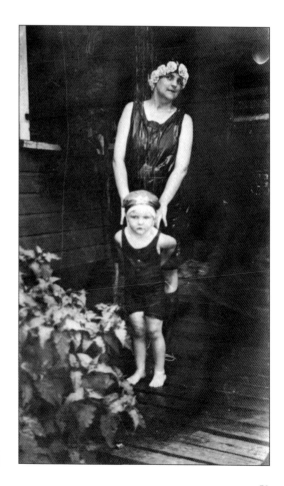

On August 14, 1927, the *Atlanta Constitution* praised the new Brookwood Hills swimming pool and park as "one of the most beautiful scenic effects" in Atlanta. In subsequent years, the facility's natural setting continued to attract admirers, enhancing the neighborhood's popularity. Sadie Burdett and her young son Billy (Arthur Jr.) pose here in their swim costumes around the time the pool launched. (Courtesy of Lisa Burdett Paine.)

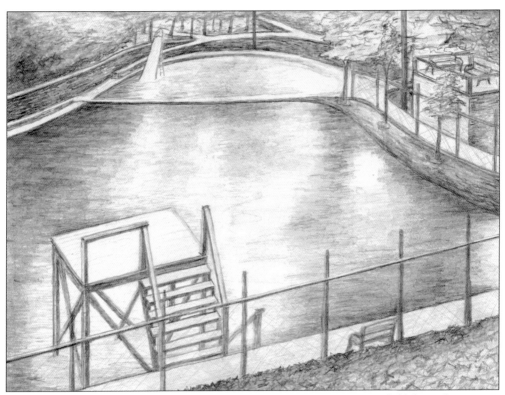

The original swimming area, 300 feet in length, was in two parts: a spring-fed lake with concrete sides and a sand bottom, and a separate concrete pool filled with city water. The lake was deep enough for a high diving platform, as seen in the sketch above and in the 1932 photograph below of brothers McCary and Perry Ballard. Initially, Burdett Realty operated the swimming area, charging 10¢ admission for neighborhood residents and their guests. Despite its popularity, the revenue was not sufficient to meet its operating costs, leading to the mortgage of the pool and its temporary closure during the Great Depression. (Above, drawing by Claire Burdett Simpson; below, courtesy of Anne McCary Ballard.)

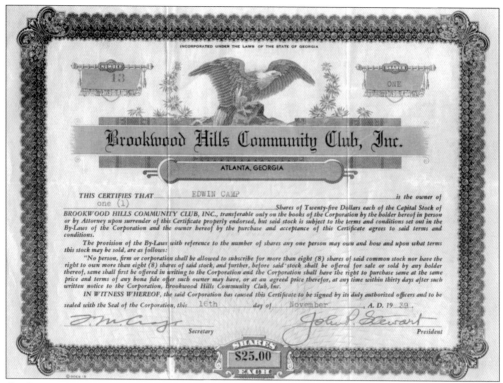

On June 14, 1939, Brookwood Hills Community Club Inc. was formed by a group of neighbors to operate the pool and the park. The door-to-door sale of $25 stock certificates raised enough capital to release the mortgage held by Emory University on the 5.8-acre site. Burdett Realty subsequently donated the remaining land value to the Community Club, which has operated the pool and the park ever since. (Courtesy of Bruce D. Wanamaker.)

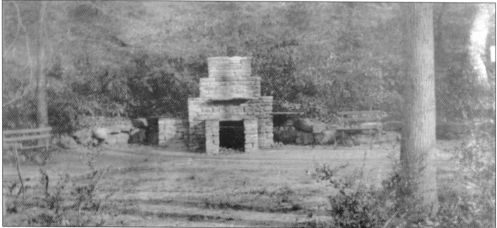

The Brookwood Hills Garden Club was formed in 1938 by Agnes Rhodes (Mrs. Clarence A. Rhodes), of 129 Brighton Road, for the "improvement and beautification of Brookwood Hills." Its first project, in October 1938, was a carnival followed by an evening dance in the dry swimming pool to the music of Graham Jackson's Orchestra. The funds raised, though earmarked for the purchase of the park, were redirected toward park beautification, including the construction of this grill. (Courtesy of AHC, Brookwood Hills Garden Club records.)

In the early years, the park offered few amenities other than a gathering spot for pick-up games of football and baseball, with teams often formed from "rival" streets. Until the 1950s, children who lived south of Palisades Road attended Spring Street Elementary School, while those north of it attended E. Rivers Elementary. The school divisions further solidified the team identities but did not undermine the neighborhood's general sense of camaraderie. (Courtesy of William A. Dunlap.)

Badminton became increasingly popular as a family sport in the 1930s, spurred by YMCA classes and the enthusiasm of screen stars such as Ginger Rogers. Charles Palmer and his family, of 40 Woodcrest Avenue, were also fans of the sport, as seen in the photograph below of them playing with friends. Note that they are dressed in the appropriate sporting attire of the late 1930s. (Courtesy of the Charles F. Palmer Collection, MARBL.)

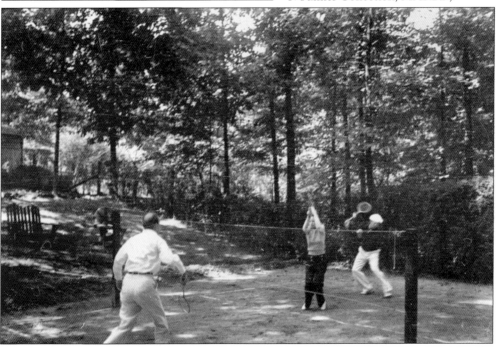

INFANTILE PARALYSIS CASES IN GEORGIA

	CASES 1944 - 1945		DEATHS 1944 - 1945	
JANUARY	1	2	•	•
FEBRUARY	1	1	•	•
MARCH	•	2	•	•
APRIL	•	3	•	•
MAY	3	8	•	1
JUNE	14	17	1	1
JULY	32	22	•	•
AUGUST	17	25	4	1
SEPTEMBER	14	12	1	1
OCTOBER	11	22	1	1
NOVEMBER	4	10	1	•
DECEMBER	•	5	•	1
	97 (COL.)	129 (COL.)	8 (COL.)	6 (white)

PATIENTS IN HOSPITALS - DEC. 1, 1945

WARM SPRINGS	22
GRADY	17
AIDMORE	4
UNIVERSITY, AUGUSTA	1
COLORED	
TUSKEGEE INSTITUTE	4
	48

From the first appearance of polio in 1916, the infection rate grew each year, turning healthy young children into paralysis victims within hours. The disease struck hardest in the heat of summer and early fall. City children and rural children were equally vulnerable and, as seen on the chart above, polio ignored racial barriers. The only defense was for parents to isolate their children, leading to lonely summer days indoors. The first polio vaccine was not widely available until 1957, but Dr. Ellsworth Cale of 75 Palisades Road had access to an early supply. Neighborhood children lined up outside his back door to get inoculated. Below is the diary of concerned mother Nancy Simpson Porter. (Above, courtesy of GSU-L; below, courtesy of Nancy Porter Godfrey.)

> **THURSDAY** **August 23, 1951**
> A.M.
> 9 Dr. Roberts says keep the children away from swimming, movies, crowds, on account of polio. Sis missed Frank's party Monday on account of the polio scare. Talked to Caroline Krans

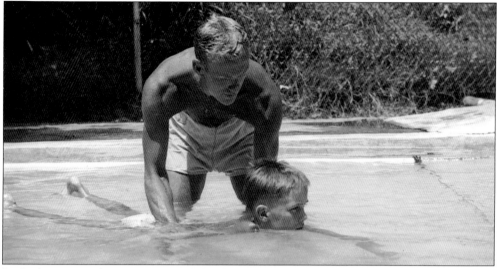

In the late 1940s, the Community Club sold additional shares to finance the renovation of the swimming area. The lake was drained, the pool was deepened, and a war-surplus filter was installed. Above, a lifeguard gives swimming lessons to a young resident in the newly renovated pool. Working as a lifeguard was a rite of passage for teenagers like Bill Dunlap (below), who appreciated the perks of the job. Nevertheless, it was serious business. Brighton Road resident Nancy Simpson Porter recorded in her diary in August 1952: "Billy Dunlap has been an excellent lifeguard. He is strict and right on the job." Unfortunately, in the pool's history, there have been two drowning victims: John Brady, age seven, who died in 1929 as a result of a heart condition, and lifeguard Mac Shreve, who was trapped by a drain in the pool bottom in 1977. (Above, courtesy of AHC; below, courtesy of William A. Dunlap.)

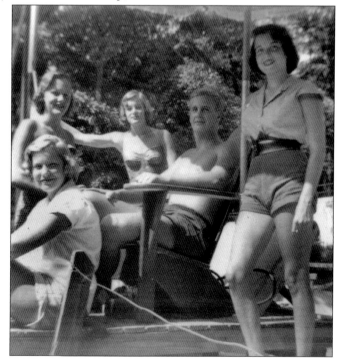

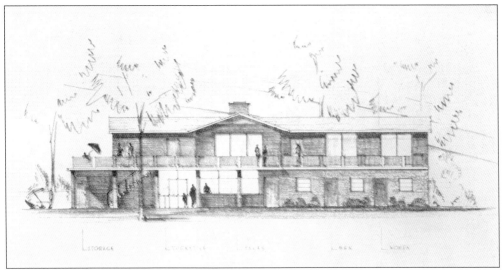

Once drained, the lake became a swampy no-man's-land. In a 1956 letter to the membership, the Community Club proposed a grand plan to improve the recreation area. Tennis courts would replace the overgrown swimming lake and the park would get a children's play area, a new grill, and a baseball diamond. Plans included an upgrade to the bathhouse to connect it with a new concession area, but also on the drawing board for a later date was a large enclosed clubhouse (above). The club's letter announced an assessment of $25 per family membership, and an annual dues increase of $5 per person. The final project was finished by November 1957, but the dream of a two-story enclosed clubhouse never came to fruition. (Above, courtesy of Anne Kenan Donaldson; below, courtesy of Frank D. Inman.)

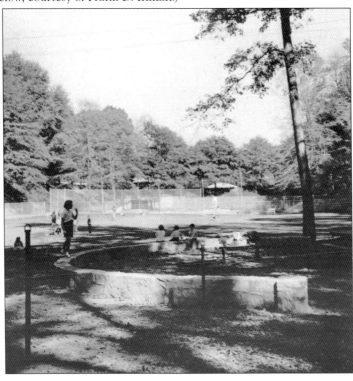

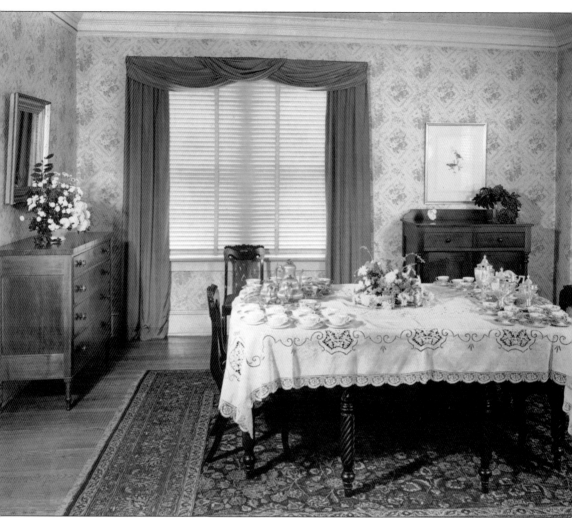

With its primary focus on the beautification of the neighborhood, the Garden Club attracted both serious gardeners and garden lovers who were skilled at fundraising. Always at the heart of the organization was the opportunity it provided for social interaction based on a shared love of flowers and gardens. Membership in the Garden Club came with the daunting obligation to host, once every five years, the monthly luncheon meeting for the 45 active members. This photograph shows a member's dining room table set for coffee and a luncheon in the late 1930s. (Courtesy of AHC, Brookwood Hills Garden Club records.)

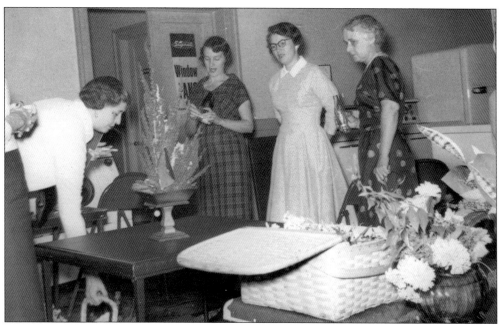

Meetings often included lectures on flower arranging and gardening, as seen above in 1956. That same year, under the direction of club president Mary Trippe, the Garden Club voted to provide funds for the decoration of the pool changing rooms and to make a Christmas donation to the International Red Cross for Hungarian Relief. During World War II, the club kept a Victory garden at Egleston Hospital, baked cookies for soldiers departing from Brookwood station, raised money for war bonds, and rolled bandages. In 1962, it improved the landscaping of the neighborhood entrance at Brighton Road (below), with members providing much of the physical labor. In the more than 75 years since the club's inception, its monthly meetings have been characterized by garden education, fundraising, landscape efforts, and socialization. (Both courtesy of AHC, Brookwood Hills Garden Club records.)

Nancy Belle Keeler began teaching dance to young girls in the early 1930s. Her first studio, in her family's garage at 82 Brighton Road, had a mirror, a dance bar, an upright piano, and a changing room. Seen above at her last recital in 1952, "Miss Nancy" accepts a wedding present for her upcoming marriage to Dusty Rhodes. She returned to teach dance at the Westminster Schools after her husband's untimely death five years later. Seen at left in her gypsy Halloween costume is Lynn Petters of 73 Palisades Road. After attending classes with Miss Nancy, she went on to further training and danced with the Atlanta Ballet in high school. (Above, courtesy of Fran Patterson; left, courtesy of Lynn Petters Cochran-Schroder.)

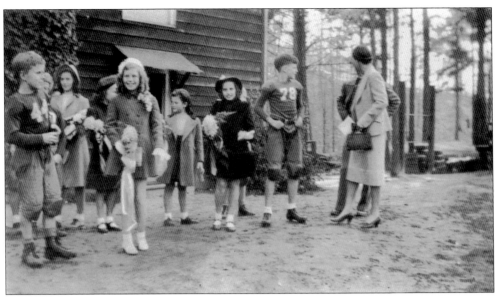

The Fritz Orr camp offered boys and girls after-school recreation and sports education and was a favorite among young Brookwood residents. In the December 1939 photograph above, Walter Mitchell (No. 78) of 45 Montclair Drive celebrates the end of the season with the big game between the Midgets and the Giants. In attendance are his mother Ethel Mitchell (right) and young female fans. By the late 1940s, when John Wolfe (below) of 58 Camden Road donned a Midget uniform, the Fritz Orr program had so many Brookwood Hills campers that a bus picked them up at E. Rivers Elementary School and then delivered them home later. The boys reinforced the skills learned at the camp through the many pick-up games played at the park and on empty lots scattered throughout the neighborhood in the 1930s and early 1940s. (Above, courtesy of Wade T. Mitchell; below, courtesy of John D. Wolfe.)

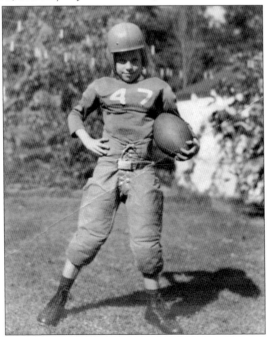

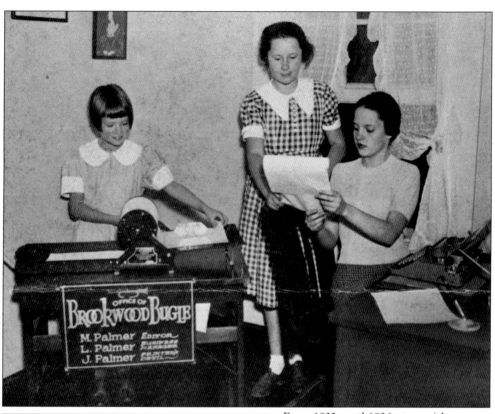

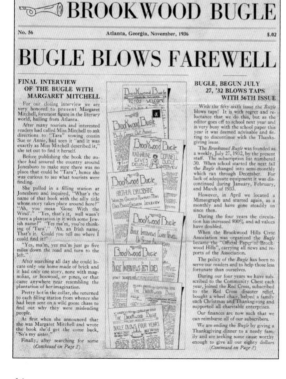

BROOKWOOD BUGLE

No. 56 Atlanta, Georgia, November, 1936 $.02

BUGLE BLOWS FAREWELL

FINAL INTERVIEW OF THE BUGLE WITH MARGARET MITCHELL

For our closing interview we are very honored to present Margaret Mitchell, foremost figure in the literary world, hailing from Atlanta.

After many tourists and interested readers had called Miss Mitchell to ask directions to "Tara," vowing cousin Sue or Annie, had seen it "and it was exactly as Miss Mitchell described it," she set out to find it herself.

Before publishing the book the author had scoured the country around Jonesboro to make sure there was no place that could be "Tara", hence she was curious to see what tourists were finding.

She pulled in a filling station at Jonesboro and inquired, "What's the name of that book with the silly title whose story takes place around here?" "Ah, you mean 'Gone With the Wind'." "Yes, that's it, well wasn't there a plantation in it with some Jewish name?" "Yes ma'm, you're thinking of 'Tara'." "Ah, an Irish name, That's it. Could you tell me where I could find it?"

"Yes, ma'm, yes ma'm just go five miles down the road and turn to the left."

After searching all day she could locate only one home made of brick and it had only one story, none with magnolias, or boxwood, or pines, or that came anywhere near resembling the plantation of her imagination.

Pretty hot in the collar, she returned to each filling station from whence she had been sent on a wild goose chase to find out why they were misleading people.

At first when she announced that she was Margaret Mitchell and wrote the book she'd get the come back, "So's my sister."

Finally, after searching for some
(Continued on Page 2)

BUGLE, BEGUN JULY 27, '32 BLOWS TAPS WITH 56TH ISSUE

With the fifty-sixth issue the *Bugle* blows taps! It is with regret and reluctance that we do this, but as the editor goes off to school next year and is very busy with the school paper this year it was deemed advisable and fitting to discontinue with the Thanksgiving issue.

The *Brookwood Bugle* was founded as a weekly, July 27, 1932, by the present staff. The subscription list numbered 30. When school started the next fall the *Bugle* changed into semi-monthly which ran through December. For lack of adequate equipment it was discontinued during January, February, and March of 1933.

However, in April we located a Mimeograph and started again, as a monthly and have gone steadily on since then.

During the four years the circulation has increased 800%, and ad values have doubled.

When the Brookwood Hills Civic Association was organized the *Bugle* became the "Official Paper of Brookwood Hills", carrying all news and reports of the Association.

The policy of the *Bugle* has been to serve our readers and to help those less fortunate than ourselves.

During our four years we have subscribed to the Community Chest each year, joined the Red Cross, subscribed to the Red Cross disaster relief, bought a wheel chair, helped a family each Christmas and Thanksgiving and supported all charitable enterprises.

Our finances are now such that we can reimburse all of our subscribers.

We are ending the *Bugle* by giving a Thanksgiving dinner to a needy family and are seeking some cause worthy enough to give all our eighty dollars
(Continued on Page 2)

From 1932 until 1936, sisters (above, from left to right) Jeannette, Laura, and Margaret Palmer produced a neighborhood newspaper, the *Brookwood Bugle*, in former servants' quarters in their parents' garage at 40 Woodcrest Avenue. Sold by subscription at 10¢ an issue, the paper had a circulation of over 200. Margaret, the editor, conducted interviews with local and national celebrities, catching some as they passed through the Brookwood train station. An article about the paper appeared in the *Atlanta Constitution* in 1932. It was subsequently picked up by the Associated Press wire service and was reprinted in 20 other cities, and even as far away as Sweden. For the final issue (left), in November 1936, Margaret scooped an interview with Margaret Mitchell, who had published *Gone With the Wind* that June. "I don't like to write," Mitchell confessed to the *Bugle*. "In fact, I'd rather hoe potatoes." (Both courtesy of AHC.)

First cousins Grady Black Jr. (left) and Walter Wellborn Jr. (right), who was known as Pete, were great-grandsons of renowned journalist Henry Grady. In 1935, they joined with their friend Lea Richmond to create a natural history museum called the WLG Museum (for Walter, Lea, and Grady) in the garage behind the Wellborn home at 80 Palisades Road. Although Grady Black did not grow up in the neighborhood, his childhood years spent there led him to purchase two homes in Brookwood Hills as an adult. (Courtesy of Betty Black.)

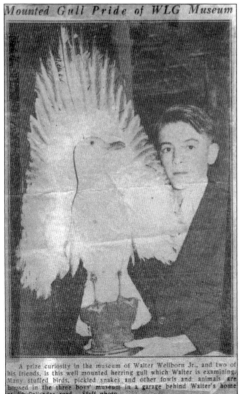

Mounted Gull Pride of WLG Museum

A prize curiosity in the museum of Walter Wellborn Jr., and two of his friends, is this well mounted herring gull which Walter is examining. Many stuffed birds, pickled snakes, and other fowls and animals are housed in the three boys' museum in a garage behind Walter's home at 80 Palisades road. Staff photo.

A newspaper article on the opening of the WLG Museum on August 29, 1935, reported that the budding naturalists were "mighty anxious to make money and interest the public in nature." The boys spent three years catching and stuffing snakes and birds and mounting them for exhibition, becoming taxidermy experts in the process. On display in the museum were stuffed owls, freak turtles, a herring gull, a rare roseate spoonbill wading bird, and a live possum with her young. (Courtesy of Betty Black; reprinted with permission of the *Atlanta Journal-Constitution*.)

The Flexy Racer, a wheeled adaptation of the Flexy Flyer snow sled, was a favorite mode of transportation in the rolling landscape of Brookwood Hills. Boys, as well as some daring girls, rocketed down the neighborhood's steep hills, oblivious to the danger and without today's protective helmets. A favorite and fast downhill route for children racing Flexy Racers and home-built soapbox cars led from the top of Brighton Road to Montclair Drive, turning at Wakefield Drive, and cruising to a stop at the pool. (Courtesy of Betsy Crosby.)

In the 1940s and 1950s, the Coca-Cola Company encouraged neighborhood children to become entrepreneurs, delivering cases of Coke for their summer sales. Although some children sold Coke door-to-door via Flexy Racers and red wagons, young Nancy Porter of 255 Brighton Road purchased an official Coca-Cola stand, similar to those carried on the roof of the delivery truck below. This photograph was taken in 1951 in a nearby neighborhood. (Courtesy of GSU-L.)

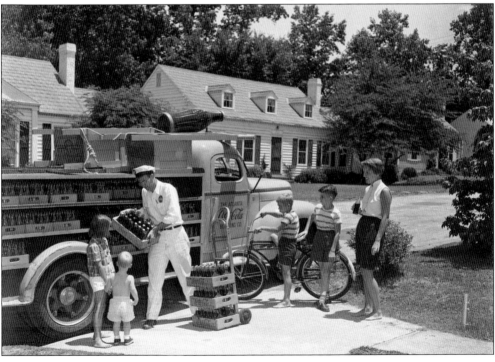

Most Brookwood Hills children from the 1920s to the 1960s spent their playtime outdoors, inspired by their wooded surroundings. Boyhood favorites included Cowboys and Indians and re-creations of both the Civil War and World War II, with crab apples as ammunition. In later years, "soldier" Edgar Dunlap (left), seen here with his "warrior" brother Billy, developed a passion for homing pigeons, which he kept in a coop behind his home at 26 Palisades Road. (Courtesy of William A. Dunlap.)

Seen here in the early 1930s are, from left to right, George Adams, Sam Mangham, and Jack Olden, posing on their bicycles in the Olden driveway at 34 Brighton Road. Children felt free to travel by bicycle both within the neighborhood and along Peachtree Street. Stewart Roberts of 16 Woodcrest Avenue remembers riding his bicycle to Piedmont Park, where he and his brother Bill played pickup football for the Tigers against their grade school rivals, the Mooses. (Courtesy of Jeanne Olden Barlow.)

A rare snowstorm in February 1936 paralyzed the city for many days, to the delight of Brookwood Hills children. Here, in front of 45 Montclair Drive, the home of Ethel and Walter Mitchell, domestic employees and sisters remembered only as Willy and Lilly frolic with the children in the snow. Just a few years later, the two sisters, who shared living quarters in the basement, joined the Great Migration to Detroit. (Courtesy of Wade T. Mitchell.)

Between the 1920s and the 1960s, delivery trucks plied the roads of Brookwood Hills, delivering groceries, prescriptions, ice, coal, laundry, milk, potato chips, eggs, and even live chickens. In the late 1950s, sisters Lindsey and Blair Ison were especially fond of the Highland Bakery truck, which they would wave down to purchase a chocolate cake for $2. It was quickly consumed in the backyard, hidden from parental eyes. (Courtesy of AHC.)

An 11-year-old Walter Mitchell (left) stands with Camden Road pal Malcolm Turner in 1940. They met when Walter, new to the neighborhood at age four, was sent outside to find playmates. Walter later recalled that their lifelong friendship began with Malcolm's cheerful response to his plaintive question, "Does anyone want to play with a little boy?" Many early residents developed enduring friendships with their Brookwood Hills playmates, some spanning seven decades or more. (Courtesy of Wade T. Mitchell.)

Dogs roamed free in Brookwood Hills, including Brenda, seen here with Bruce Logue in the early 1950s. Stewart Roberts's dog Rex liked to follow his bicycle to the Tenth Street movie theater, while John Wolfe's dog Copper rode the North Fulton school bus on its neighborhood rounds. A "really good dog fight," recalls Skip Petters, was a staple summer entertainment for the children on Palisades Road and Woodcrest Avenue. (Courtesy of Bruce Logue.)

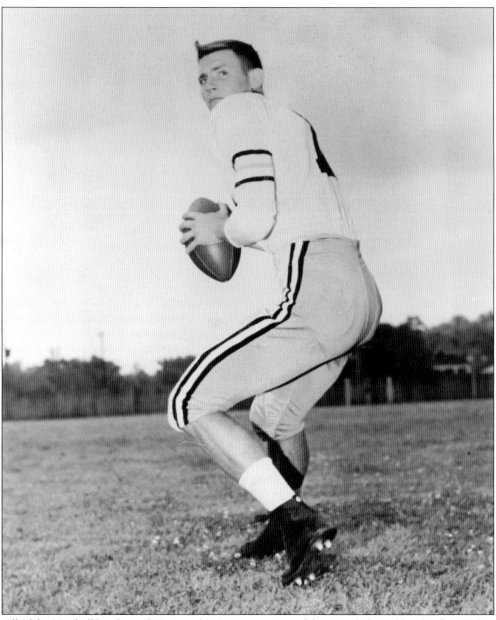

All of the Mitchell brothers of 45 Montclair Drive were star athletes, including oldest brother Walter (track) and middle brother Billy (basketball), but it was Wade Mitchell who gained lasting fame on the football field for Georgia Tech. Playing both quarterback and defensive back, he received many accolades, including being named an Academic All-American in 1955. He graduated in 1957 with the highest grade point average of his class. His father, Walter Mitchell Sr., had also been a Georgia Tech athlete, and Wade credited his father's coaching for the development of his and his brothers' athletic skills. Admiring neighborhood boys remember their backyard high-jump pit and Wade's ability to throw the football behind his back the entire length of the neighborhood park. Wade Mitchell went on to become a successful banker and was inducted to the Academic All-American Hall of Fame in 1996 and the Georgia Sports Hall of Fame in 2004. (Courtesy of Georgia Tech Sports Information.)

In the 1940s and early 1950s, the Turner family home, at 41 Camden Road, housed son Rob Turner's snake collection, a source of fascination for neighborhood boys. A mesh-covered pit in the backyard contained water snakes, while venomous rattlesnakes, cottonmouths, and copperheads were kept in cages in the basement. Rob's daughter Cay later inherited her father's passion, becoming a zookeeper at the Birmingham Zoo, specializing in reptiles. (Courtesy of GSU-L.)

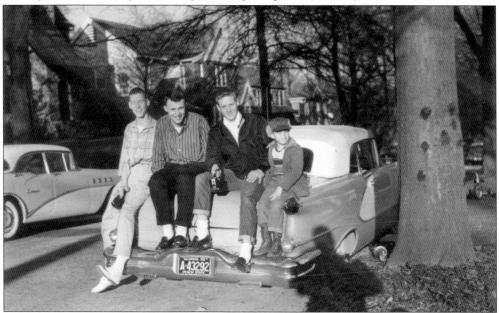

Hanging out on Camden Road in 1956 are, from left to right, John Wolfe, Arthur Wick, Joe Wesley, and Billy Wesley. Though just beginning to drive by the time this photograph was taken, Wolfe and his teenage friends also enjoyed building forts in the Clear Creek woods and adding motors to their Flexy Racers. The year 1956 was burned in the memory of Wolfe's Huntington Road buddy Jimmy Shepherd, who witnessed Elvis Presley's magnetic performance of "Heartbreak Hotel" at the Paramount Theater. (Courtesy of John D. Wolfe.)

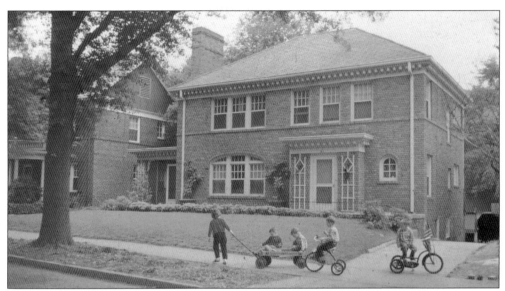

In the 1950s and 1960s, children considered the relatively flat Woodcrest Avenue a playground in itself. Jane Carter, who lived with her family at 50 Woodcrest from 1957 to 1965, recalled a time when the street was populated with 35 children, 36 dogs, 35 bikes, and 35 Flexy Racers. Above, John Carpenter (center, on tricycle) and Jim Carpenter (on back of wagon) play with friends about 1954. Their father, John Wallace Carpenter (below), operated a ham radio in the basement of their home at 31 Woodcrest Avenue. Using a map and globe, he would point out the exotic locations of fellow operators. "We were fascinated," recalled a former childhood neighbor. "Alaska seemed as far away as the moon." Lucy Carpenter Vance remembered the service her father rendered with his radio, sending assistance to victims of a South Seas flood. (Above, courtesy of John W. Carpenter Jr.; below, courtesy of Lucy Carpenter Vance.)

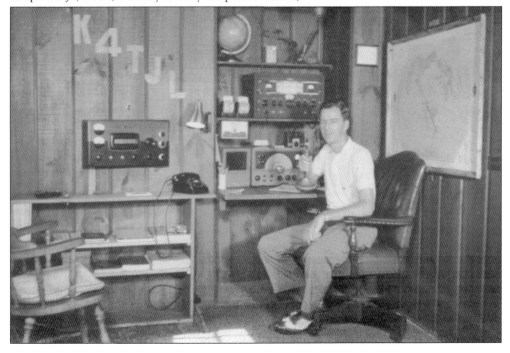

Palisades Road neighbors (from left to right) Lynn Petters, Skip Petters, Bruce Logue, Bill Shultz, and Carolyn Logue roamed as a pack on summer days, returning home only when the dinner signal rang. The Petters had a cowbell, the Logues had a bike horn, and other mothers used triangles, whistles, and taxi horns. The warning bell sounded at 6:15, giving children 15 minutes to slide home for the start of dinner, promptly at 6:30. (Courtesy of Lynn Petters Cochran-Schroder.)

A favorite place for children to visit was the backyard garden at 115 Palisades Road, the home of Mildred and Edwin Camp, who were known to regulars as Granny and Grandpa Camp. Mrs. Camp, the daughter of Joel Chandler Harris, grew especially close to young Lynn Petters, passing on a love of gardening. The fondness they shared is evident in this "signed" book of Uncle Remus stories Mrs. Camp presented to her. (Courtesy of Lynn Petters Cochran-Schroder.)

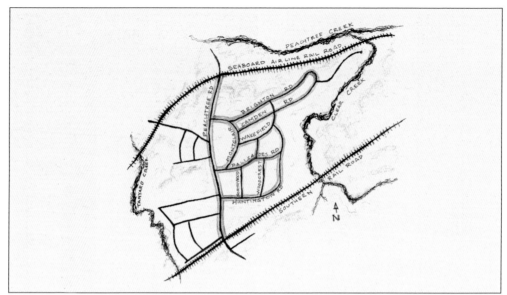

Two railroads, a busy thoroughfare, and two creeks create the boundaries of Brookwood Hills. What most developers would consider detriments to sales were considered assets by the neighborhood children. Camden Road resident John Turman Jr. fondly remembered the whoosh of air from passing trains on hot summer nights, bringing to his open window the sweet smell of gardenias from the bushes outside. (Drawing by Claire Burdett Simpson.)

The Seaboard Railroad passed behind the home of Jimmy and Edith Henderson, at 250 Brighton Road. Their sons Ross and Edward considered it a major attraction, racing to place pennies on the tracks to be flattened and climbing the train trestle that crossed Peachtree Creek. The trains did not just attract neighborhood boys. Margaret Evins Shirley remembers a train stopping one day to give her and her girlfriends a short ride. (Courtesy of James R. Henderson Sr.)

74

Marilyn Dorn Staats, who used a fictionalized version of Brookwood Hills in her novel *Looking for Atlanta*, spent her childhood in the late 1940s and early 1950s playing in the woods near Clear Creek. "We smoked rabbit tobacco in the woods; cracked open hickory nuts with stones; hunted for birds' nests; brought home box turtles as pets. We played Tarzan and Jane, swinging from the thick vines that hung from the hardwood trees," she wrote. The creek was an equal attraction, as seen in the photograph below of, from left to right, Lisa Burdett, an unidentified friend, and Clint Burdett. Recalled Staats, "We sunbathed on a granite boulder in the creek, played mumble-peg on its sandy shores, jumped from rock to rock across the creek, and climbed up through the woods on the other side to stand at the crest of the hill and look down at the Southern Railway yard." (Above, photograph by Kay Summers; below, courtesy of Lisa Burdett Paine.)

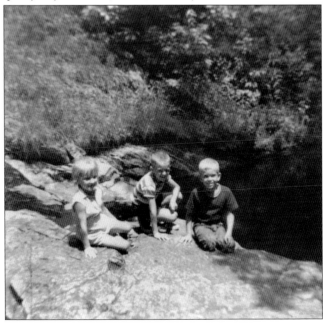

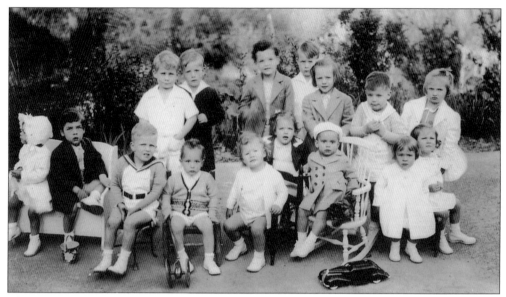

This 1939 birthday party at 67 Brighton Road for little Howard Hailey Jr. (center right, in white rocking chair) was attended by neighborhood children, including Pegram Harrison (back row center, dark hair) of 39 Palisades Road. Harrison would later remark, "The Rawsons lived next door, and it seemed like Butch had a birthday once a month, which was not fair." In the 1960s, Harrison returned with his family to buy a home on Brighton Road. (Courtesy of Laura Hailey Bowen.)

Seen here in 1948 are Virginia (left) and Florence Henderson. After the Hendersons lost their Huntington Road home during the Depression (see page 37), Matt Henderson went to medical school. Dr. Henderson and his wife, Florence, then returned to Brookwood Hills in the late 1930s to purchase 54 Camden Road. In 1958, Virginia and her husband, Dennis Brown, bought her parents' home, where they raised their own daughter Genna, a current resident of Brookwood Hills. (Courtesy of Genna Brown.)

During the turbulent war years of the early 1940s, three Wheeler siblings from this photograph, Eula, Olin, and Kate (second row, second, fifth, and sixth from the left, respectively), rented a home together at 76 Huntington Road. In 1967, their nephew Sidney Wheeler moved to Brookwood Hills with his family. The Wheelers' twins, John Wheeler and Molly Wheeler Jackson, subsequently bought neighborhood homes and are now raising another generation in Brookwood Hills. (Courtesy of John Wheeler.)

Arthur Burdett Sr. lived to see several of his grandchildren grow up in the neighborhood he helped build. Seen here in the early 1960s are, clockwise from bottom left, Jenny Miles, Robert Miles (Jenny's father), Sadie Burdett, Arthur Sr., Curtis Miles, Arthur Burdett Jr., and Lisa Burdett. By this time, Robert Miles and Arthur Jr. had taken over the active business of Burdett Realty. (Courtesy of Lisa Burdett Paine.)

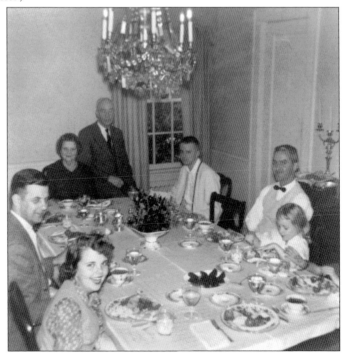

Brookwood Hills was the home of many prominent Atlantans, including Robert Strickland Sr., the president of Trust Company Bank of Georgia (now SunTrust Bank). Serving as president from 1937 until his untimely death in 1946, Strickland lived with his wife, Jessie, and their two children at 89 Brighton Road. He also played an important role in Brookwood Hills, helping to incorporate the Brookwood Hills Community Club in 1939. His son Robert Strickland Jr., seen at left around the time of his father's death, followed in his father's footsteps at Trust Company, becoming its president in 1976. Bob Strickland and his wife, Telside "Tatty," returned in 1960 to purchase the house across the street, at 94 Brighton Road. They are seen below with Jessie Strickland and, from left to right, Doug, Walter, and Billy. Missing from the picture is Robert Jr.'s fourth son, Bobby, the family photographer. (Both courtesy of the Strickland family.)

Five

Where Peachtree Meets Brookwood

1920s–1960s

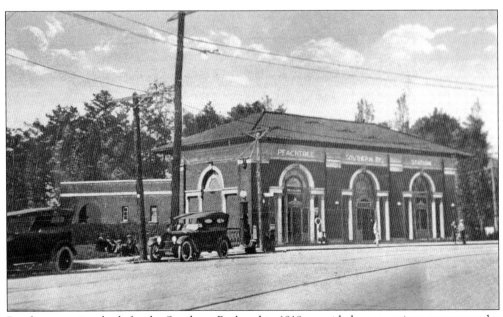

Peachtree station, built for the Southern Railroad in 1918, provided a convenient gateway to the world at large for the growing number of suburban residents north of Atlanta, and particularly for those in the Brookwood area. Designed by Neel Reid of Hentz, Reid & Adler, Brookwood station, as it quickly became known, had the classical dignity of many of the fine homes that graced this part of Peachtree Street. (Courtesy of AHC.)

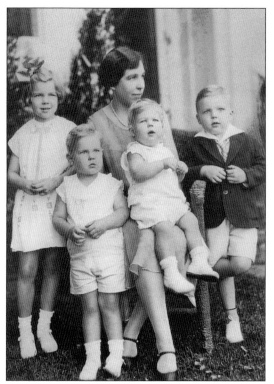

For the Varney Stuart Ward family of 84 Wakefield Drive, Brookwood station was a familiar landmark. Mr. Ward sold insurance for the textile industry, and his weekly business circuit through his sales territory was by rail, since the only paved highway in Georgia was the connection between Atlanta and Macon. On late Friday afternoons, Virginia Ward and her four children waited eagerly at Brookwood station for the return of their road-weary "daddy." (Courtesy of the Varney Stuart Ward family.)

Many suburban passengers preferred to board the train at Brookwood station to avoid the hustle and bustle of the downtown terminal station. Here, Elizabeth Barnett (left) and Neel Whitman pose for a photograph before their 1925 adventure to New York City to join Macy's junior executive training corps. Their train, the Crescent Limited, carried passengers from New Orleans to the Northeast in luxury Pullman cars served by porters. (Courtesy of Mary Whitman Heisel.)

About 3,000 cheering fans and a brass band greeted young Bobby Jones upon his triumphant return from his first major golf championship, the 1923 National Open in Inwood, New York. Admirers hoisted him on their shoulders before carrying him to a waiting automobile for the drive to a downtown reception. As his reputation grew over the ensuing years, so did the crowds. Jones often paused at Brookwood station, where his family climbed aboard for the short trip to the main terminal downtown. Trains bearing celebrities, including Metropolitan Opera stars, tennis champion Bitsy Grant, and fighter Jack Dempsey, paused at Brookwood station, offering local residents a close-up glimpse of famous passengers. Reporters would jump on or off the train at Brookwood, grabbing a quick interview as celebrities either arrived in town or left for the Northeast. (Courtesy of the Bobby Jones Collection, MARBL.)

Brookwood Hills was built in the early 1920s as a streetcar suburb, although automobiles were quickly overtaking public transportation. For those heading south on Peachtree Street to downtown Atlanta or north to Buckhead, the streetcar (above), and later the rubber-tired trackless trolley, remained an efficient mode of transportation. Brookwood Hills continued to function as a streetcar suburb even as trolleys were replaced by gas buses in the late 1940s. (Courtesy of AHC.)

Charles F. Palmer of 40 Woodcrest Avenue was a real estate developer interested in public housing and urban renewal. The drive from his home past the Tanyard Bottom slums, related in his autobiography *Adventures of a Slum Fighter*, led him to organize the development of the first federally financed public housing, Techwood Homes. He is seen here in 1935 giving first lady Eleanor Roosevelt a tour of the development. (Courtesy of the Charles F. Palmer Collection, MARBL.)

Techwood Homes was dedicated by Pres. Franklin Roosevelt (above) in 1935. Charles Palmer's efforts so impressed President Roosevelt that he appointed him defense housing coordinator in 1940. Returning for a 1944 speech to the Atlanta Rotarians, Palmer decried the deterioration of famed Peachtree Street from Brookwood station to Peachtree Creek, blaming the "misplaced stores, filling stations and drive-ins" on the lack of zoning laws and city planning. (Courtesy of AHC.)

The train from Warm Springs, Georgia, bearing Pres. Franklin Roosevelt's casket arrived in Atlanta at 1:30 p.m. on April 13, 1945. A short time later, it began its passage northward. Martha Mann Pentecost recalled that students at nearby Washington Seminary, initially giddy and talkative at their early dismissal, quickly grew sober as they joined the grieving crowd lining the tracks at Brookwood station to watch the train crawl by. (Courtesy of Georgia Archives, Lamar Q. Ball Collection, lball0674.)

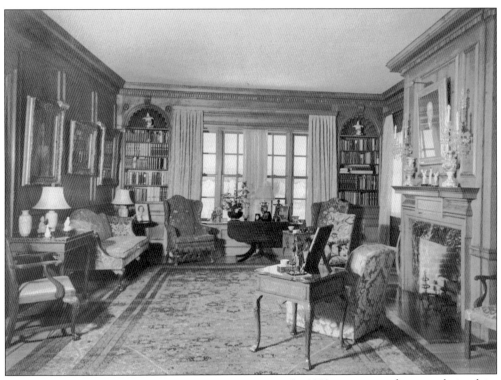

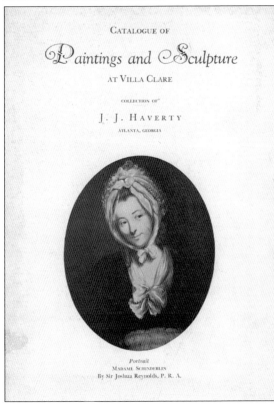

In 1918, two years after completing his home, Villa Clare, at 2020 Peachtree Road, J.J. Haverty's wife, Clara, died. In deep mourning, Haverty's health faltered and he closed up Villa Clare while he sought recovery. Two years later, with his health restored, he began to refocus his energies on collecting art. Encouraged by his Peachtree Road neighbor J. Carroll Payne, he became active in the Atlanta Arts Association. In 1926, he helped establish the High Museum of Art, providing financial support for many years. Until his death in 1939, Haverty pursued his newfound passion for fine art and arts education. To encourage public appreciation of the arts, he opened Villa Clare (above) for Sunday tours, personally showing visitors his paintings by Sargent, Cassatt, Twachtman, and Tanner, while his indulgent daughter May served tea and cookies to visitors. Many of the Villa Clare paintings were later donated to the High Museum's permanent collection. (Both courtesy of the Haverty family.)

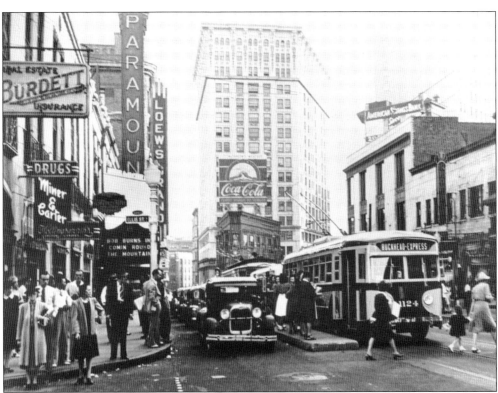

The offices of the Burdett Realty Company (above, left foreground) and those of most other Brookwood Hills residents were located downtown in the 1940s. Many residents, including Mary Dunlap of 26 Palisades Road, commuted to work by way of the Buckhead Express, a trackless trolley with rubber wheels powered by an overhead cable. Dunlap supported herself and her three sons through her job at the Specialty Shop at Rich's Department Store. (Courtesy of Georgia Archives, Vanishing Georgia, ful0993-86.)

Rich's was the destination for many shoppers, including Clara Gann and her mother, Clara Hand Gann, of 142 Brighton Road, seen here in 1944. A trip on the trolley or bus downtown to shop for back-to-school clothes was a ritual eagerly anticipated by many girls and their mothers. It often concluded with lunch or tea at the Frances Virginia Tea Room, located in the Collier Building, above Burdett Realty. (Courtesy of Clara Mont-Claire O'Shea.)

Living within walking distance of a grocery store was important for families like Nancy Porter's, whose father had a job as a traveling salesman, requiring the use of their only car. Brookwood Supermarket, seen here in 1951, was located at 1705 Peachtree Street, across from Brookwood station. By the early 1950s, the stretch of road adjacent to Brookwood Hills was crowded with small businesses serving the neighborhood's everyday needs. (Courtesy of GSU-L.)

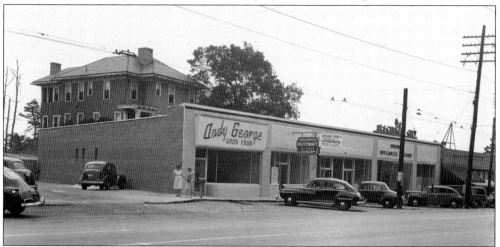

In the 1940s and 1950s, Brookwood Village, a row of commercial establishments on Peachtree Road between Brighton and Palisades Roads, offered a grocery store, a drugstore, a restaurant, a dry cleaner, a hair salon, a flower shop, and a hardware store. During the next 60 years, businesses would come and go, but the variety of offerings would remain virtually the same, providing a place for neighborhood interaction as well as summer employment for teenage residents, who worked in the stockrooms or made deliveries. (Courtesy of GSU-L.)

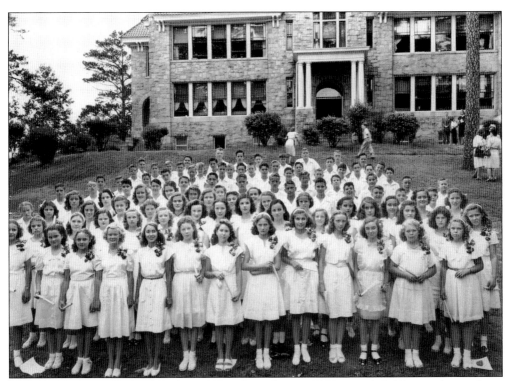

E. Rivers Elementary School, built in 1917 and seen here in 1946, served children in the northern section of Brookwood Hills through seventh grade. Shortly after school was dismissed on September 17, 1948, a fire broke out, burning the school to the ground. Children like Jimmy Shepherd ran all the way from Brookwood Hills to witness the stunning event. Marilyn Dorn Staats recalled that the girls wept in dismay, while the boys cheered the flames on. (Courtesy of Wade T. Mitchell.)

Until the school was rebuilt, children attended classes at Second-Ponce de Leon Baptist Church and at The Temple. E. Rivers reopened in 1950 and won an award for its modern design. Jay Parham, seen here with his teacher in June 1962, rode the bus to and from Brookwood Hills, but many earlier residents preferred to walk or ride their bikes the 0.7-mile distance, stopping for a treat across the street at Fred's Fruit Emporium. (Courtesy of Betty Parham Nichols.)

On December 15, 1939, Margaret Palmer, the daughter of Charles and Laura Palmer of 40 Woodcrest Avenue, led the grand march at the Junior League Ball celebrating the Atlanta movie premiere of *Gone With the Wind*. Margaret was chosen by a Junior League contest to wear actress Vivien Leigh's gown, based on the measurements of her figure. Her waistline, and Leigh's, she confessed, were closer to 22 inches, as opposed to Scarlett O'Hara's fictional 17. (Courtesy of AHC.)

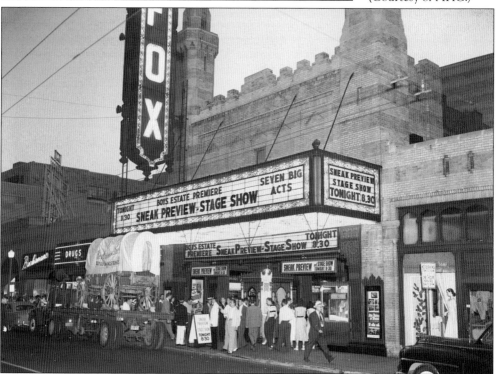

Neighborhood children, unaccompanied by their parents, routinely traveled along Peachtree by bus or trolley to attend movies and other entertainment downtown at the Fox Theater, or at the Buckhead and Garden Hills Theaters, north of the neighborhood. Saturday morning films featuring Roy Rogers, the Lone Ranger, and Hopalong Cassidy drew both girls and boys, who found riding the air-conditioned bus a treat in itself. (Courtesy of GSU-L.)

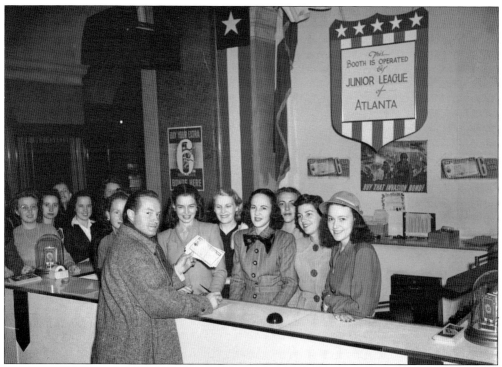

Brookwood Hills residents served in World War II both overseas and through volunteer work on the home front. Dance teacher Nancy Keeler worked for the Red Cross transporting wounded soldiers on leave in Atlanta. Asked to squire Bob Hope around on his trip to Atlanta promoting war bonds, she recalled his pronouncement that he preferred to sit in the front so he could get a better look at her legs. (Courtesy of GSU-L.)

Peachtree Street provided the conduit for community involvement for many residents. A 1974 survey of 150 Brookwood Hills families revealed their participation in 79 different service organizations. Among the charities served by neighborhood women was the Junior League's Atlanta Speech School, located from 1950 to 1967 in the former Haverty family home, Villa Clare, at 2020 Peachtree Road. Today, many residents support the Shepherd Center, a rehabilitation hospital, which stands in its place. (Courtesy of GSU-L.)

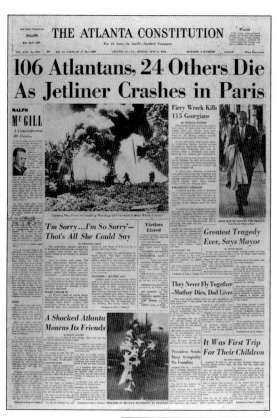

A plane crash at Orly Airport in Paris on June 3, 1962, killed 106 Atlantans on a trip sponsored by the Atlanta Arts Association to raise interest in the fine arts. Among the victims were Ruby Adair of 58 Montclair Avenue and Annette Payne of 228 Camden Road, both widows in their early sixties. Mrs. Adair was not on the original roster. She had thrown a bon voyage party for Payne and her other friends, who then persuaded her to join them. The loss of so many community-oriented citizens devastated the city, and set back the development of the burgeoning arts community by decades. Atlanta mayor Ivan Allen lost many personal friends in the crash. Associate city attorney Edwin Sterne, who lived at 142 Brighton Road, flew with him to Paris on June 4, 1962, to assist in the grim task of identifying the remains. (Left, courtesy of AHC, reprinted with permission of the *Atlanta Journal-Constitution*; below, courtesy of AP Images.)

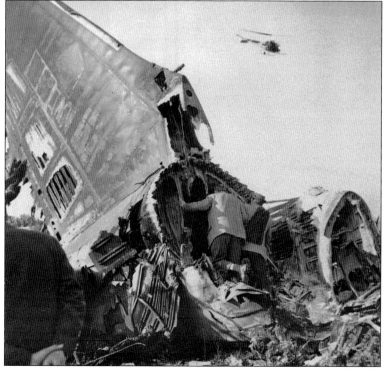

Edith Henderson, who lived with her husband, Jimmy, and their sons at 250 Brighton Road, was one of the nation's few female landscape architects when she won the 1964 Woman of the Year Award for Atlanta professionals. She is seen here accepting congratulations from Atlanta mayor Ivan Allen. A popular writer and lecturer, she worked on numerous public and commercial projects, as well as private gardens in Brookwood Hills and other neighborhoods. (Courtesy of James R. Henderson Sr.)

Attorney Elbert P. Tuttle was a Brookwood Hills resident who lived at 61 Palisades Road from the late 1920s until the early 1940s. He assisted Piedmont Hospital in its 1940 conversion into a nonprofit corporation and served on its board of trustees until 1966. He was appointed judge of the US Court of Appeals for the Fifth Circuit in 1960 and was known for upholding federal civil rights laws. (Courtesy of Piedmont Healthcare archives.)

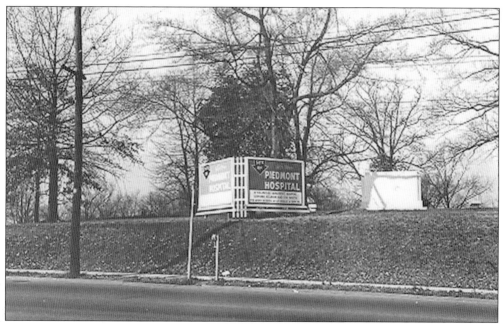

One of the important early decisions voted on by Piedmont Hospital's new board of trustees was the 1943 purchase of the former property of Jack J. Spalding, Deerland. Spalding had died in 1938, and his will directed that Deerland could not be used as a residence after his death. Following Deerland's demolition, this sign announcing the future home of Piedmont Hospital stood on the site for several years. (Photograph by John Slade; courtesy of Piedmont Healthcare archives.)

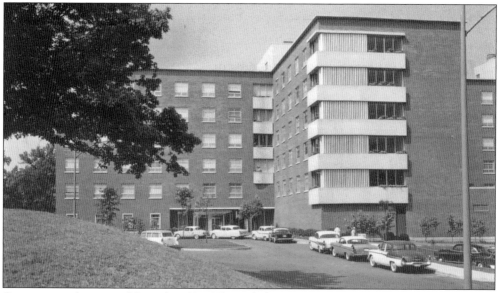

Construction began on November 29, 1954, and the new Piedmont Hospital opened its doors on March 26, 1957. A convoy of 15 ambulances transported 64 patients from the old hospital on Capitol Avenue (now the site of Turner Field) to its Peachtree Road location. The hospital has since had a profound influence on the Brookwood area, providing many Brookwood Hills residents with healthcare services, as well as a place to work and volunteer. (Photograph by Gabriel Benzur; courtesy of Piedmont Healthcare archives.)

Shortly after Piedmont Hospital opened its doors in 1957, young Dr. Mark P. Pentecost Jr. and his wife, Martha, purchased a home at 129 Brighton Road. Dr. Pentecost, who later became chairman of the board of directors of Piedmont Medical Center, had grown up at 21 Palisades Road (see front cover). Like many subsequent Piedmont Hospital physicians and healthcare professionals, he enjoyed being able to walk to his office from his home in Brookwood Hills. (Courtesy of Martha M. Pentecost.)

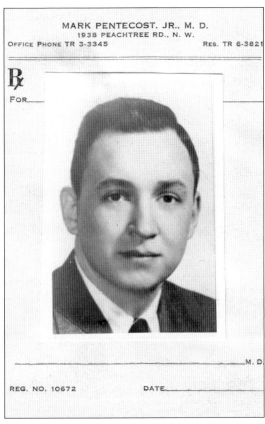

MARK PENTECOST, JR., M. D.
1938 PEACHTREE RD., N. W.
OFFICE PHONE TR 3-3345 RES. TR 6-3821

℞

FOR____

_____ M. D.

REG. NO. 10672 DATE_____

In 1951, an unsuccessful lawsuit by Brighton Road residents opposing the rezoning of the Potts farm at 2025 Peachtree Road resulted in the construction of the 14-story, 612-unit Darlington Apartments (below). The loss of this private suit spurred the Brookwood Hills Community Club to become involved in fighting development battles on behalf of the neighborhood as a whole, gaining in the process a reputation for being strong, vocal, and committed on zoning matters. (Courtesy of AHC.)

Between 1957 and 1965, the appearance of Peachtree Street looking north from Brookwood station to Palisades Road changed dramatically with the loss of tree cover, as seen in these two photographs. Among the new buildings constructed in those years were the Atlanta Masonic Center, at 1690 Peachtree Street, the First National Bank Building, at 1776 Peachtree Street, the Jewish Community Center, at 1745 Peachtree Street, and what became known in Brookwood Hills as the "black building" (it was subsequently painted grey), at 1819 Peachtree Street. In the late 1990s, the proposed development of Brookwood Place Shopping Center, near Brookwood station at 1735 Peachtree Street, prompted a new demand from the Brookwood Hills Community Club: replacement of street trees and the installation of sidewalks to promote pedestrian traffic. (Both courtesy of GSU-L.)

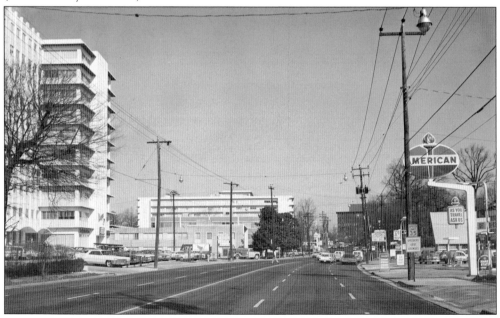

Six

NEW ENERGY WITH A
NEW GENERATION

1960s–2000

In 1966, the Brookwood Hills Community Club hired Adley Consultants to analyze the neighborhood and propose actions for its protection. The report identified two family types that are still prevalent today: couples in their late 30s with young children, and retired couples whose children had grown up in the neighborhood. Subsequent efforts by the younger generation identified in the report proved instrumental to the preservation and protection of Brookwood Hills. (Courtesy of Deborah Stacy Gebhardt.)

bROOKWOOD
hiLLs

*an inventory of the community today
and a guide for its future development...*

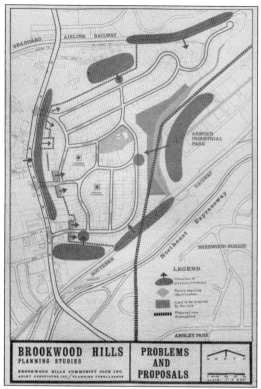

BROOKWOOD HILLS
PLANNING STUDIES
BROOKWOOD HILLS COMMUNITY CLUB INC.
ADLEY ASSOCIATES, INC. / PLANNING CONSULTANTS

PROBLEMS
AND
PROPOSALS

The Adley study identified several problems that threatened to destabilize the neighborhood, such as a proposed cut-through from Palisades Road to Armor Drive Industrial Park, and the extension of West Peachtree Street through a 55-acre urban forest east of the neighborhood. The report advocated the purchase of this forest, partially owned by the Collier family, which the board gradually acquired in three parcels over the next 20 years. (Courtesy of Deborah Stacy Gebhardt.)

In 1971, Jimmy Henderson (below, center) passed the gavel to newly elected president Alex Summers (second from left) while other board members (from left to right) John Hunsinger, Sam Donaldson, and Barrett Hawks looked on. The 1971 board, which included its first female member, Rhea Eskew, voted to remove racial restrictions from the bylaws and initiated efforts to purchase the Clear Creek woods to provide a buffer to development. (Courtesy of Kay Summers.)

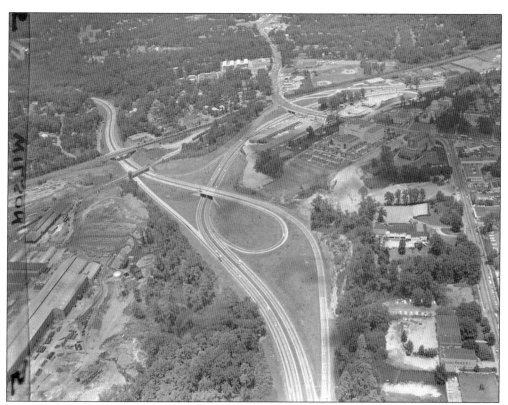

The Brookwood Interchange, seen above in 1959, was the subject of fierce negotiation in the 1970s. After the neighborhood succeeded in defeating the proposed West Peachtree Road extension in 1974, it fought the Georgia Department of Transportation's proposal to widen Interstate 85. Extensive meetings with government officials resulted in a compromise that lowered the grade of the project, reduced the number of lanes from 12 to 10, and defeated an access ramp that would have towered over Huntington Road. Of equal concern was the 1971 proposal by the Metropolitan Atlanta Rapid Transit Authority to create a northwest subway line with a station at Peachtree and Twenty-sixth Streets. The route, opposed by both Brookwood Hills and suburban Cobb County, would have required the removal of several Huntington Road homes. The proposal was eventually defeated in a referendum. (Above, courtesy of AHC; right, courtesy of Nancy Kennedy.)

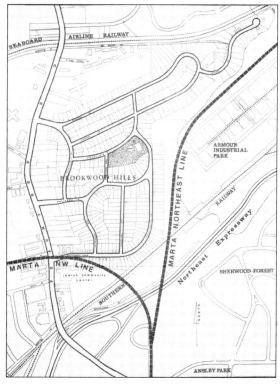

Jim Stokes, seen here in the early 1980s with his wife, Esther, battled a number of transportation threats in the 1970s as a young lawyer serving as the neighborhood's zoning representative and president. During that period, the Community Club relied increasingly on the pro bono professional expertise of board members, including lawyers Barrett Hawks, Dan O'Connor, Jim Wildman, Jerry Luxemburger, Felton Jenkins, and John Helms, architect Alex Summers, and many others. (Courtesy of Alston & Bird.)

In the 1970s, Republican state senator Mike Egan provided valuable service to the Community Club by facilitating access to officials at the Georgia Department of Transportation and other state agencies. He also served as deputy attorney general of the United States under Griffin Bell during the Carter administration. Egan, his wife, Donna, and their six children were longtime residents of 97 Brighton Road. (Courtesy of Mike Egan.)

In 1978, Brookwood Hills applied for historic district status in the National Register of Historic Places. Public hearings were attended by many neighbors, some enthusiastic and others expressing concern. Opposition lessened with the understanding that National Register status would not control exterior changes, but would deter federal encroachment. In 1980, the two older sections of the neighborhood, including the park and the pool, were added to the National Register, effectively protecting the later sections as well. Although the neighborhood qualified for historic district status under the City of Atlanta's guidelines, it applied for, and received, the lesser designation of conservation district in 1994, which mandates only that exterior changes be submitted to the Atlanta Urban Design Commission on an "advise and comment" basis. With a few notable exceptions, residents have abided by the recommendations. (Both, courtesy of Elaine Luxemburger.)

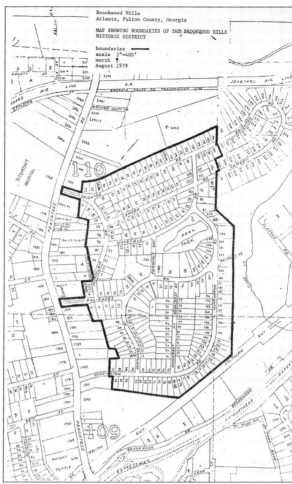

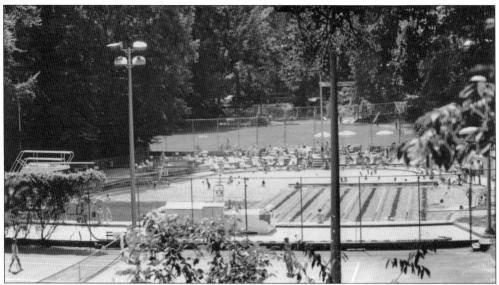

In the 1960s and 1970s, the neighborhood witnessed a rejuvenation as the homes of some of the earliest residents began to go on the market. Young families were especially attracted to the neighborhood's pool and tennis courts. Although membership in the Community Club was open to all residents, there was soon a waiting list for nonresident members anxious to join what many considered to be the best pool in the city. (Courtesy of Anne Kenan Donaldson.)

A swim team program did not make a consistent appearance until 1979, under the direction of swim coach Alan Joel, who served for six years. The first swim team is seen here with the high diving board, which was later removed for insurance reasons. Competing against other Fulton County community pools in the greater Atlanta area, the team recorded impressive achievements at state meets. (Courtesy of Anne Kenan Donaldson.)

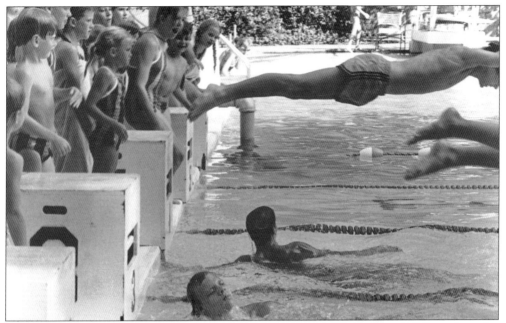

As the swim team grew in popularity in the 1980s and 1990s, Brookwood Hills embraced a new subcommunity of team members and their parents, including swimmers from outside the neighborhood. With increased activity, the Community Club hired a resident manager, Anne Donaldson, who oversaw pool operations for 10 years. During her tenure, the end-of-season Dog Swim, held during the pool's last operating hour each September, became a new annual tradition. (Photograph by Kay Summers.)

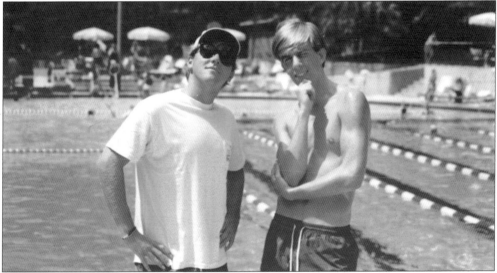

A summer job at the pool has been a rite of passage for generations of Brookwood Hills teenagers, beginning with a stint at the concession stand at age 14 and often working up to a coveted position as a lifeguard, reserved for those 16 and older. Seen here in the early 1990s are lifeguards Nils Thompson (left) and Ed Helms, who became a film and television star known for his roles in *The Office* and *The Hangover*. Helms grew up on New Camden Road. (Courtesy of Anne Kenan Donaldson.)

In the 1970s and early 1980s, a six-member tennis committee spurred activity on the Brookwood Hills courts. A popular event was the annual summer championship, which drew over 150 participants, including adults and children. Play began on Friday evening and, after four rounds of matches, concluded on Sunday night with a party and the presentation of trophies. Jack Heisel, the longtime tennis committee chairman, is seen here in 1982 giving a lesson to the neighborhood's Cub Scout pack. (Courtesy of Jack Heisel.)

For many years, the Brookwood Hills "Shady Ladies" competed in the Atlanta Lawn Tennis Association League. In 1976, they credited their success to their coach, neighborhood resident Zahner Reynolds, who played number one at the University of Georgia. The 1976 C-Three team included, from left to right, (first row) Linda Copeland, Marge Henson, Beverly Stacy, Barbara Persons, and Dinah Moog; (second row) Susan Simpson, Lyn Jenkins, Julie Jenkins, Sue Trotter, and Pat Gearon. (Courtesy of Julie G. Jenkins.)

In the early 1970s, a proposal to the Community Club to convert the unkempt neighborhood park into tennis courts was opposed vigorously by the Garden Club and neighbors such as landscape architect Sam D'Angelo. In 1973, efforts began for a joint initiative between the Community Club and the Garden Club to clean up and restore the park, spearheaded by Anne Donaldson (above, right). Several fathers' workdays were organized, and the Garden Club, neighbors, and Brownie Troop 317 planted eroding banks with sprigs of ivy and daffodil bulbs. New play equipment was installed, financed by the Community Club and a $3,000 Garden Club donation. The southern bank of the park, an old-growth forest, was reclaimed as a nature trail and Audubon sanctuary. For its efforts, the Garden Club received an award in 1975 from the National Council of State Garden Clubs. (Both courtesy of AHC, Brookwood Hills Garden Club records.)

As this photograph from the early 1980s shows, the restoration of the park brought it new life. Improvements added over the years included a gazebo and picnic area, designed in 1978 by neighbor Sam D'Angelo, a climbing wall, a new paved track, and play equipment. The park continues to function today as a community gathering place for birthday parties, parades, and holiday celebrations sponsored by local realtors and business owners. (Courtesy of AHC.)

In the years following the desegregation of the Atlanta public school system, private schools attracted a growing number of Brookwood Hills children. Although several residents remained loyal to, and supportive of, E. Rivers Elementary School, gone was the easy camaraderie that developed among neighborhood children attending the same public school. Instead, parent-sponsored clubs and sports teams, such as the 1978 Mets, seen here, fostered friendships among neighborhood children attending different schools. (Courtesy of Fran Patterson.)

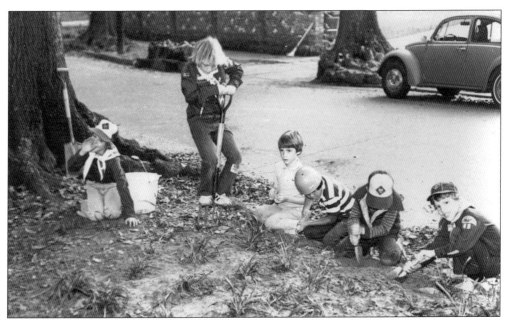

Societal changes in the 1970s and 1980s sent many Brookwood Hills mothers into the workplace, although several still devoted their free time to community service. Mothers led Cub Scout troops and Girl Scout troops that performed service projects throughout the neighborhood, such as the planting of Mondo grass at the park entrance (above) and picking up park litter. In 1976, neighborhood Girl Scouts delivered Christmas candy houses to elderly residents such as widower Chet Covey (below). In a poignant letter, Covey thanked his Brighton Road neighbor Debbie Stacy: "You and your precious little friends brought joy to a lonesome old man this evening." The neighborhood's compact setting and shady sidewalks allow interaction among various generations, helping to keep its elderly residents from feeling isolated. (Above, courtesy of AHC; below, courtesy of Beverly and David Stacy.)

In 1974, Sadie Burdett, the widow of Brookwood Hills developer Arthur Burdett, was interviewed for the first volume of a new neighborhood publication, the *Brookwood Byword*. The *Byword* lasted throughout the 1970s. In 1986, the newspaper was revived under a new name, *Brooknotes*, by Brighton Road resident Nan Clarke, with funding by realtor Virginia Reynolds. *Brooknotes* has run continuously ever since, and has been sponsored since 1993 by neighborhood realtors and longtime residents Patti Junger and Sarah Hagood. (Courtesy of Claire Burdett Simpson.)

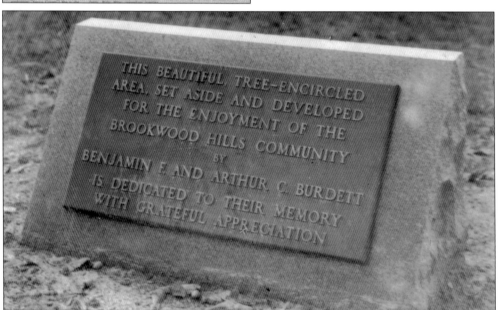

On August 23, 1974, with the restoration of the neighborhood park underway, the Garden Club and the Community Club memorialized the Burdett family's earlier gift of the recreation area with a marker at the pool entrance. Present at the dedication were Sadie Burdett, granddaughters Cay and Ellen Burdett, and daughter Polly Burdett Miles. Polly met her husband, Robert, in the 1930s when they collided accidentally in the Brookwood Hills pool and later raised her three children, Jenny, Rob, and Curtis, across the street at 95 Wakefield Drive. (Courtesy of AHC, Brookwood Hills Garden Club records.)

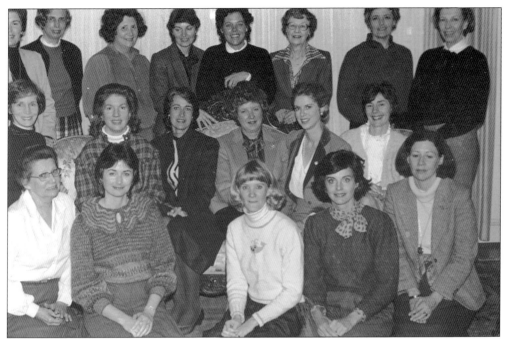

As the city of Atlanta grew up around Brookwood Hills, property crime became an unfortunate side effect, coming to a head in late 1978 and early 1979, when the neighborhood experienced a rash of break-ins within an 18-month period. Residents rallied with a neighborhood watch program instigated by Brighton Road resident Liz Primm (above, first row, far left). When Brookwood Hills hired off-duty Atlanta policeman Barry Miller to patrol the neighborhood in 1979, crime dropped precipitously. Today, Officer Miller (left), pictured in 1995 with his son Barry Miller Jr., continues to patrol Brookwood Hills, assisted by four off-duty officers. Decades earlier, the neighborhood had felt equally compelled to retain security services. Bicycle-riding deputy sheriff W.F. Bolen was hired in 1940 to watch for prowlers and "to stop a younger generation practice of swimming in the Brookwood pool by confiscating discarded clothing." (Above, courtesy of Liz Primm; right, courtesy of Betsy Crosby.)

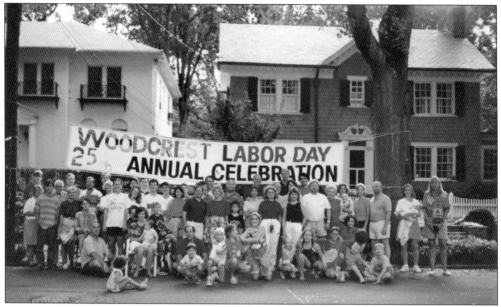

The Woodcrest Labor Day block party, begun in 1966 by resident Polly McLeod, ran continuously until 2007. Seen here is the 1991 celebration of the party's 25th anniversary. Traditionally, John Hunsinger's bugle opened the festivities, followed by a watermelon scavenger hunt, a bubble-gum blowing contest, and a parade. Northwood Avenue and Huntington Road also had longstanding block party traditions, including the crowning of the oldest residents as king and queen. (Courtesy of Marge Henson.)

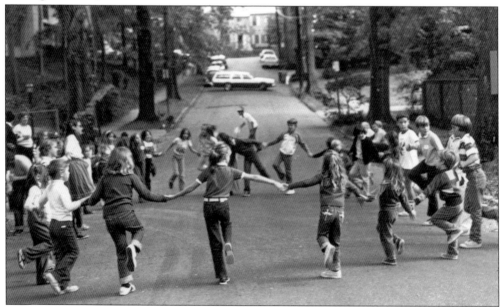

The Garden Club held a harvest festival in the park in 1981. Neighborhood families were invited to bring their picnic suppers and join in activities like volleyball, football, and bingo. Cars blocked off traffic to Parkdale Way, where children gathered to square dance. The festival was a reprise of the Garden Club's first fundraiser 43 years earlier, which featured a fishpond, a country store, and fortune-telling. (Courtesy of AHC, Brookwood Hills Garden Club records.)

Fourth of July in Brookwood Hills offers the unique opportunity to have a front-row seat at the Peachtree Road Race, the largest 10-kilometer race in the nation, which runs along Peachtree in front of the neighborhood. Since 1978, when the race destination moved to Piedmont Park, neighbors have awakened to the sounds of cheers, megaphones, and news helicopters. In the 1988 photograph above, one of the 60,000 participants gets a refreshing spray after climbing Cardiac Hill, near Piedmont Hospital, which sits across from the neighborhood's Brighton Road entrance. At right in 1995, residents (from left to right) Julie Jenkins, Steve Parker, Ann Parker, and Bebe Withers encourage Julie's husband, Felton, and other neighborhood participants. (Above, courtesy of Piedmont Healthcare archives; right, courtesy of Betsy Crosby.)

Best-selling author Pat Conroy lived in Brookwood Hills in the 1980s. His house at 17 Palisades Road had a detached two-story garage (seen on the cover of this book) that he used as an office. For the French edition of his novel *Prince of Tides*, translated in French as *Le Prince des Marées*, Conroy was photographed in January 1988 in front of the Georgian-style facade of his neighbor's home at 14 Palisades Road. He later apologized, explaining that the French photographer did not think his own Tudor-style home conveyed the proper Southern ambience. On a visit to Atlanta in 2010, Conroy expressed to the *Atlanta Journal-Constitution* his admiration for another Brookwood Hills best-selling author, Kathryn Stockett, commenting that her novel *The Help* "was a brave and gallant book, an infinitely compassionate book and I cannot wait to meet her." (Photograph by Ulf Andersen.)

Shortly after Robert Shaw accepted the position of music director of the Atlanta Symphony Orchestra in 1967, he chose to make Brookwood Hills, just two miles north of Symphony Hall, his home. He is seen below with his beloved Bentley in 1968 in front of his home, 78 Wakefield Drive, where he married Caroline Sauls Hitz in December 1973. Renowned for his award-winning direction of the Robert Shaw Chorale in the 1960s, his work with the Atlanta Symphony Orchestra and Chorus garnered 17 Grammys. He received the first Guggenheim Fellowship given to a conductor and was honored in 1991 at the Kennedy Center. Shaw is considered the dean of choral music, known for his classic choral arrangements with his collaborator Alice Parker, as well as his vast catalogue of masterwork recordings, most notably Handel's *Messiah*, J.S. Bach's *Mass in B Minor*, and Verdi's *Requiem*. (Above, courtesy of Atlanta Symphony Orchestra; below, courtesy of Alex Hitz.)

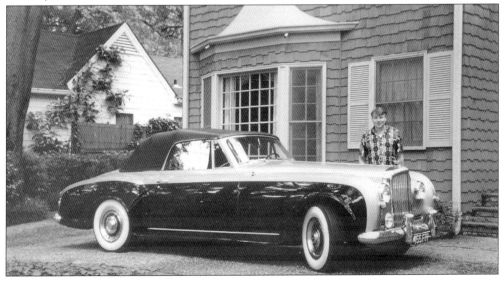

Brookwood Hills has been the home of many extended families for multiple generations. Members of the Parham family have lived continuously on Brighton Road for the last 60 years. Seen here in 1967 are, from left to right, Helen Brown Orr, of 252 Brighton Road, her daughter Barbara Parham, of 70 Brighton, and her grandchildren Betty and Jay Parham. Betty and her husband, Nick Nichols, and their family continue to live on Brighton Road. (Courtesy of Betty Parham Nichols.)

In 1964, King & Spalding attorney Bradley Hale and his wife, Anne, purchased 61 Brighton Road from the William Parker family, who had owned the house for two succeeding generations. The Hales' son Sheffield, seen here with his father, also became an attorney and shared the family interest in history and historic preservation, later heading the Atlanta History Center. In 1994, he returned to Brighton Road with his wife, Elizabeth, and their children, where they lived for several years, just two doors from his parents. (Courtesy of F. Sheffield Hale.)

In the 1970s, the oak trees planted by B.F. Burdett had reached their full maturity, branching to form a leafy canopy overhead, as seen in this 1976 Brighton Road photograph. Many years earlier, the sun-loving crepe myrtles planted by Burdett had been crowded out by the shade. An arborist report to the neighborhood in 1972 predicted that the water oak trees could last another 40–50 years. (Courtesy of Liz Primm.)

The health of the water oaks was compromised by the limited room for root growth between the sidewalk and the street and by aggressive pruning by the power company. Liz Primm, seen here, became the neighborhood's first tree chairman. The power company found her to be a formidable adversary after a standoff with their tree-trimming crew. "Georgia Power was our No. 1 enemy," she told the *Atlanta Constitution* in 1999. "We were at war." (Courtesy of the Primm family, reprinted with permission of the *Atlanta Journal-Constitution*.)

In summer months, with the shade trees combating the heat island effect of the surrounding asphalt and office towers, one could experience a 10-degree drop in temperature upon entering the neighborhood. "Driving into Brookwood Hills was like entering a green haven," said former resident Fran Patterson. Here, Jimmy Sweeny (left) and Tom Patterson relish Camden Road's shady shelter in 1984. (Courtesy of Fran Patterson.)

The branches of the mature canopy are vividly outlined in this 1982 photograph of Northwood Avenue after a winter storm. The dramatic beauty of the scene was tempered by growing neighborhood concerns about trees dropping large branches or being toppled by high winds and ice. As trees began to succumb to nature, the Community Club started replanting programs, assisted by donations from individual neighbors and the Garden Club. (Courtesy of Anne Kenan Donaldson.)

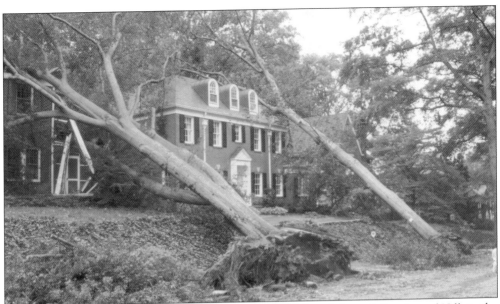

Hurricane Opal, with wind gusts up to 100 miles per hour, plowed through Brookwood Hills in the early-morning hours of October 5, 1995. The high winds slammed over 40 of the neighborhood's mature water oaks onto power lines, slate roofs, and parked cars, damaging 33 homes. None of the residents were seriously hurt, although small miracles and the sturdy construction materials of the 1920s appeared to have saved many. A sense of gratitude sprouted with community spirit, as neighbors shared food in potluck barbecues during the four days that downed trees blocked street traffic. Without electricity, phone service, or cable television, children delighted in the novelty of their transformed neighborhood, oblivious to the frustrations of adults throughout Brookwood Hills trying to deal with insurance companies and contractors. Perched below on a toppled Palisades Road tree, from left to right are Claire Gambrell, Everett Nadal, Caroline Nadal, and Jennifer Gambrell. (Above, photograph by Esther Stokes; below, courtesy of Micki Gambrell.)

1996
ACORN
AUCTION

7:00 p.m. *April 26*
84 Wakefield Drive
GREEK FEASTING

Your Catalogue is Your Ticket for
the Evening

The entire neighborhood rallied to the cause of tree replacement, led by the Garden Club. The club's April 1996 Acorn Auction, held at Katie Bollman's home at 84 Wakefield Drive, raised $32,000, thanks to donations from residents, Garden Club members, neighborhood realtors, and local businesses. That fall, the replanting began. A December 1995 report by Community Club tree chairman JoAnn Hagaman offered advice from a number of experts, who urged planting new trees in yards where possible, rather than under power lines near the sidewalk and the street. The report also suggested, as landscape architect Edith Henderson had advised 20 years before, planting a variety of oaks, elms, maples, and gingkoes to alleviate the monoculture. These recommendations have guided the tree-replacement efforts of the neighborhood ever since. In 1998, Brookwood Hills received the We Believe in Trees Award from the city's Arbor Day Partners. (Both courtesy of Betsy Crosby.)

Architects Mack Scogin and Merrill Elam were out of town during Hurricane Opal when an oak tree crashed into the ridge beam of their postwar Wakefield Drive home, causing structural rifts to the brick walls throughout. At the time of the hurricane, Scogin was serving as chairman of the department of architecture at the Harvard University Graduate School of Design. The husband-and-wife team of architects, who have an international reputation for avant-garde designs, relished the opportunity for a radical overhaul of their former "Monopoly box" house. The result, designed around a second-story, 50-foot-long lap pool, caused mixed reactions in the neighborhood but garnered plaudits from the architecture world. Despite its untraditional raw-concrete-and-glass exterior, Scogin and Elam were careful to conform to neighborhood standards regarding setbacks, volume, and height, allowing their house to blend with the rhythm of the streetscape. (Courtesy of *Atlanta* magazine.)

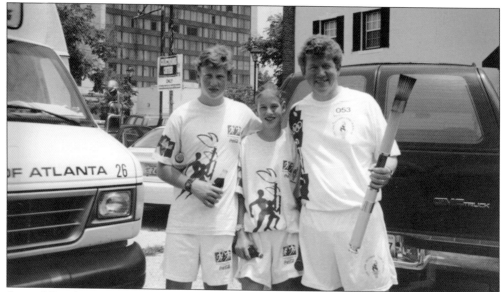

Several Brookwood Hills residents played instrumental roles in the 1996 Atlanta Olympics. Above, former Brighton Road resident Joe Bankoff was a torchbearer, running in Athens, Georgia, on July 6, 1996, escorted by his children Christopher and Margaret. He and his wife, Lisa, had worked to bring the games to Atlanta, and the entire family volunteered during the Olympics. Lisa Bankoff was in charge of part of the opening and closing ceremonies, in which Margaret performed. Former Northwood Avenue resident Mary O'Connor is seen below with swimmer Michelle Smith (left), a three-time gold-medalist and the first woman to win gold for Ireland. O'Connor served as attaché to the Irish Olympic Committee. Because of the close-in location of the neighborhood, many residents rented their homes to visitors and Olympic families, who appreciated the neighborhood's urban setting and access to public transportation. (Above, courtesy of Lisa Herron Bankoff; below, courtesy of Mary B. O'Connor.)

Seven

SUSTAINING THE OASIS

AFTER THE MILLENNIUM

At the initiative of New Camden Road resident Susan Connell, the neighborhood began to explore the idea of a reconstruction of the pool pavilion in 2000. Some neighbors balked at the proposed $1,000 assessment, but farsighted Community Club leaders persevered. Dedicated in January 2002 and built in part through a generous donation from the Dina Woodruff family, today's steep-roofed pavilion, designed by Norman Askins, Architects, is the pride of Brookwood Hills. (Photograph by Kay Summers.)

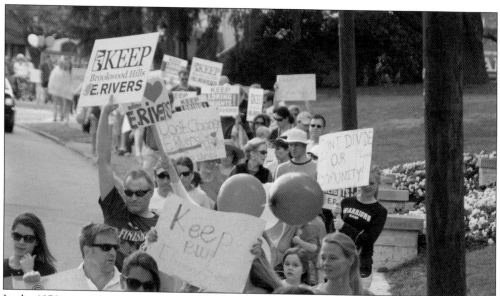

In the 1970s, neighborhood attendance at E. Rivers Elementary School was at a low point. Parental interest, however, gradually revived, and has grown dramatically in the new millennium. When the Atlanta public school system threatened to reassign Brookwood Hills students, Brookwood mothers Elizabeth Wickland, Betsy Armentrout, Amanda Szwast, and Shannon Cox led neighbors on a spirited protest march to the school on February 5, 2012, prompting a reversal of the decision. (Photograph by Webb Armentrout.)

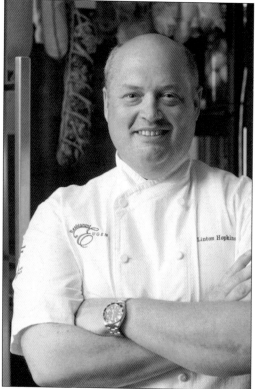

Celebrated chef Linton Hopkins grew up in Brookwood Hills. He and his wife, Gina, parents and supporters of E. Rivers Elementary School, spearheaded the creation of an organic kitchen garden at the school, providing local fruits and vegetables for 500 students through their acclaimed Restaurant Eugene. For his work with schoolchildren, Hopkins was asked to help harvest vegetables at the White House with first lady Michelle Obama as part of her Chefs Move to Schools initiative. (Courtesy of Linton Hopkins Jr.)

Tree-planting volunteers (from left to right) Bruce Wanamaker, Casey Gentry, and Amelia Wanamaker stand before a new Palisades Road shade tree in December 2009. Since 2004, Trees Atlanta has partnered with Brookwood Hills to help restore and preserve the neighborhood's urban forest. Volunteers from Trees Atlanta demonstrate planting techniques and assist in planting efforts, with the neighborhood and individual residents contributing brawn and money for the new trees. (Courtesy of Bruce D. Wanamaker.)

Neighborhood reforestation efforts started as early as the late 1970s. In 1980, a legacy from former Huntington Road neighbor Margaret Johnson was used to plant trees in her memory. Only 30 years later, the Huntington Road tree canopy seen here is the tangible result. Tree-replanting efforts were once sporadic, but between 1997 and 2012, a total of 575 new trees have been planted throughout the neighborhood. (Photograph by Kem Lee.)

In 2012, Brookwood Hills Community Club received the Golden Shoe Award from Atlanta's PEDS, an advocacy group promoting pedestrian safety. Seen here are 2011 Community Club president Ramsay Battin and board member Sara Jean Burke, who worked with residents, the City of Atlanta, and a local contractor to offer more than 90 neighbors the opportunity to replace 3,000 linear feet of broken sidewalk and curbs at a discounted price. (Photograph by Kem Lee.)

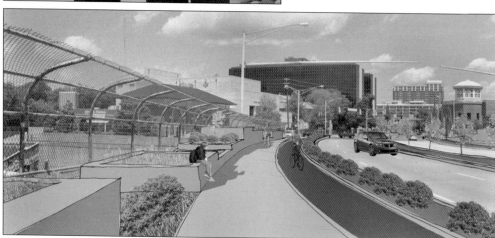

Increasing pedestrian traffic in the Peachtree corridor has been a goal of the Brookwood Alliance. Conceived in 2006 by neighborhood president Benning Grice, the alliance is comprised of five neighborhoods in the Brookwood area: Ardmore Park, the Brookwood Civic Association, Brookwood Hills, Collier Hills, and Collier Hills North. The alliance works to reduce the scale of commercial buildings, to interface with the proposed beltline, and to promote pedestrian-friendly green spaces, such as the proposed Peachtree Gateway, seen here. (Courtesy of Joe Gardner, Brookwood Alliance.)

Today, the Brookwood Hills swim and dive teams draw from both neighborhood residents and outside members. The approximately 325 participants range in age from 4 to 18. The Brookwood Hills Bullfrogs are supported by an active group of swim parents and compete against community pools in the Atlanta Swim Association. The photograph below shows swimmers and parents rallying before a home meet in 2009, with head coach Tim Storsteen (in sunglasses) in the center. In addition to regular-season meets, team activities also include a Junior Frog training program, an opening dinner, a charity swim-a-thon, a tie-dye party, movie nights, a pre-championship pasta dinner, and an end-of-season banquet. The swim team has placed well in postseason competition, winning its division in the Fulton County Championships in both 2012 and 2013. The dive team also won the Greater Atlanta Diving League Championship in 2013 after an undefeated season. (Both photographs by Kem Lee.)

Over 300 children, parents, and grandparents attended the 2011 Halloween party in the Brookwood Hills park. Staffed by parent volunteers, the annual party includes costume contests and a haunted house. The party concludes at 6:00 p.m., unleashing hordes of trick-or-treaters down neighborhood streets. Brookwood Hills, with its cul-de-sac design, narrow lots, and sidewalks, offers a safe, walkable environment for children, drawing hundreds of young goblins, princesses, and action heroes. Neighborhood houses, decorated with screeching owls, flashing lights, and menacing pumpkins, attract a steady stream of outside visitors. Below, a Brookwood Hills family picks out a pumpkin from the patch in front of the Huntington Road home of realtor Sarah Hagood. Her generous Great Pumpkin Give-Away for neighborhood residents is a 30-year Halloween tradition. (Above, photograph by Caroline Normark; below, courtesy of Sarah F. Hagood.)

Today, many female residents in the neighborhood juggle family responsibilities with jobs outside the home as doctors, lawyers, bankers, business owners, artists, and designers. Neighborhood social clubs, however, remain popular across the generations. The Brookwood Hills Friends, seen above in September 2012 after a rafting trip to the Ocoee River, is comprised of approximately 100 women in their late 20s and older who perform fundraising activities for Children's Healthcare of Atlanta, including the 2013 tour of Brookwood Hills homes. The Legacy Ladies, founded in January 2002 for current and former residents of a "certain age" (over 60), has blossomed from 15 members to 119. Seen below at the spring 2011 garden tour, cosponsored with the Brookwood Hills Garden Club, are visitors to the garden of Legacy member and landscape designer Esther Stokes. (Above, courtesy of Betsy Armentrout; below, photograph by Chet Burgess.)

With the purchase of the last Clear Creek tract in 1986, Brookwood Hills became the owner of 55 wooded acres, one of the largest contiguous urban forests in the city. Sewer and storm water overflows on the nearby Chattahoochee River, however, left Clear Creek polluted and filled with trash. Although early residents once enjoyed hunting quail and fishing bream in this wildlife area, current neighbors viewed the tract as a place best avoided. In 2006, as part of its mandated efforts to protect the Chattahoochee River's watershed, the City of Atlanta purchased a conservation easement from the Community Club, prohibiting future development. The proceeds allowed the clearance of invasive species, the planting of willow trees, and the construction of a nature trail. Caring residents like the ones above helped clear the creek of debris. Today, young explorers such as David Gebhardt (left) are rediscovering this beautiful natural resource, now named the Brookwood Hills Nature Preserve. (Both photographs by Kay Summers.)

The publication of this book celebrates the 75th anniversaries of two organizations responsible for the success of Brookwood Hills: the Brookwood Hills Community Club and the Brookwood Hills Garden Club. The Community Club, comprised of dues-paying members from both Brookwood Hills and surrounding neighborhoods, operates the swimming pool, the tennis courts, the park, and the nature preserve, sponsors neighborhood parties, and oversees the security patrol. It also functions as the official voice of the neighborhood, negotiating with government officials and developers and sending representatives to the City of Atlanta's Neighborhood Planning Unit. Its strength lies in the professional skills and commitment to the community of each of the volunteers serving on its board of directors. The Brookwood Hills Garden Club, dedicated to the improvement and beautification of the neighborhood, has helped make it the green sanctuary it is today. Since the 1970s, its fundraisers, parties, and auctions have raised over $300,000 to preserve and protect the canopy of street trees, improve the entrances and sidewalks, and landscape the pool and the park. It is by tradition a women's club of gardeners and garden lovers, with the sole exception of its beloved honorary member, Jimmy Henderson, whose passage at age 99 on May 31, 2013, was mourned by all. (Above, photograph by Kem Lee; below, courtesy of Kathleen Waldrop.)

DISCOVER THOUSANDS OF LOCAL HISTORY BOOKS FEATURING MILLIONS OF VINTAGE IMAGES

Arcadia Publishing, the leading local history publisher in the United States, is committed to making history accessible and meaningful through publishing books that celebrate and preserve the heritage of America's people and places.

Find more books like this at
www.arcadiapublishing.com

Search for your hometown history, your old stomping grounds, and even your favorite sports team.

Consistent with our mission to preserve history on a local level, this book was printed in South Carolina on American-made paper and manufactured entirely in the United States. Products carrying the accredited Forest Stewardship Council (FSC) label are printed on 100 percent FSC-certified paper.

MADE IN THE USA